IMAGES
of America

THE LINCOLN HIGHWAY
AROUND CHICAGO

Best wishes

Using a map like this one from the 1930s, cross-country travelers on the Lincoln Highway who were interested in bypassing Chicago would have followed Route 30 (the number 30 inside the shield symbol) between Schererville, Indiana, and Geneva, Illinois. But this was not the original route of the highway. In fact, the Lincoln Highway around Chicago has been rerouted in at least a dozen places since its inception in 1913. (Author's collection/Secretary of State of Illinois.)

On the cover: Please see page 21. (Courtesy of Lincoln Highway Association collection/University of Michigan.)

IMAGES
of America

THE LINCOLN HIGHWAY AROUND CHICAGO

Cynthia L. Ogorek

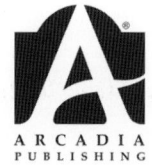

Copyright © 2008 by Cynthia L. Ogorek
ISBN 978-0-7385-5197-5

Published by Arcadia Publishing
Charleston SC, Chicago IL, Portsmouth NH, San Francisco CA

Printed in the United States of America

Library of Congress Catalog Card Number: 2007938997

For all general information contact Arcadia Publishing at:
Telephone 843-853-2070
Fax 843-853-0044
E-mail sales@arcadiapublishing.com
For customer service and orders:
Toll-Free 1-888-313-2665

Visit us on the Internet at www.arcadiapublishing.com

To Lucie Pavich Ogorek

Contents

Acknowledgments 6

Introduction 7

1. The Original Route 11

2. The Roadway de Luxe 31

3. If You Build It, They Will Come 49

4. A Different Kind of Interurban 75

5. How the Bypass Was Bypassed 95

6. The Highway as Destination 109

ACKNOWLEDGMENTS

First, thanks to all of those who opened their private collections of photographs and printed materials to me: Tom "Mad Mac" McAvoy, Paul Jaenicke, Peter "the Transcriber" Youngman, Ruth Frantz, Rita Lustig, and Bill Molony. Thank you to Ann Rackas Pate, M.S.C.E., for the information on road construction equipment and methods.

I would also like to thank David Mekarski and Bob Nale of Olympia Fields for introducing me to Gwen Russell, membership director of the Olympia Fields Country Club and keeper of the history.

This project would have stalled without the assistance of the local history librarians at the Plainfield, Aurora, Joliet, Geneva, North Aurora, South Chicago Heights, and Batavia public libraries. Barbara Paul, former chief librarian at the Chicago Heights Public Library, and Nanette Wargo, administrative librarian at the Nancy L. McConathy Public Library in Sauk Village, were particularly helpful in locating local photographs and information.

Special thanks to Kathleen Dow, manuscript librarian at the Special Collections Library of the University of Michigan, who showed extreme patience in helping me access the Lincoln Highway Association collection of the Transportation History Collection, referred to in the text as the LHA collection/University of Michigan.

Thank you, too, to Diane Rossiter of the Illinois Lincoln Highway Coalition; Barbara Perricone, president of Airpix, Inc.; Deborah Gust of the Lake County Discovery Museum/Curt Teich Postcard Archives; Lynne Mickle Smaczny, executive director of the Will County Historical Society; Kathy Powers, director of the Dyer Historical Society; Marilyn Robinson and Chris Winter of the Batavia Historical Society archives; Jane Nicoll, director of the Park Forest Historical Society archive; and Art Schweitzer and Betty Jonas of the Schererville Historical Society.

Thank you to Ron Zimmerman and Jim Buchholz of Schmeeckle Reserve, University of Wisconsin–Stevens Point, for giving me a chance to say everything out loud and providing another point of view.

Finally I would like to recognize the members of the Illinois and Indiana chapters of the Lincoln Highway Association who have worked so hard and accomplished so much in preserving the history, the spirit, and, in many cases, the physical remains of this stretch of the highway.

INTRODUCTION

There has never been a static moment on the Lincoln Highway (LH) since its route was designated by the Lincoln Highway Association (LHA) in 1913. This is not just because trucks and cars have used it day and night since then but also because in the nearly 100 years since its inception, its 3,000-plus miles have been realigned, relocated, and resurfaced countless times. This photo essay attempts to document a piece of that history as it played out on a 70-mile stretch through the Midwest—the LH around Chicago.

This portion of the highway lies between Schererville, a small town in western Indiana near the Illinois border, and Geneva, an Illinois town due west of Chicago's Loop. The LH around Chicago was a combination of section line roads and segments of the Sauk Trail from Schererville to Joliet before it turned northwest to Plainfield and then north into the Fox River valley on the road from Aurora to Geneva. This portion of the highway is significant because although the traveler would feel the attraction of Chicago, the city was, in fact, out of the way for those wanting to cross the country as quickly and as efficiently as possible. This stretch of the highway—an urban bypass, if you will—gave them the option of avoiding Chicago but also provided three connecting or "feeder" routes for those who wanted to visit the "big city."

Elsewhere in the country, the route's designers had chosen ways to get motorists through cities. For example, the highway began at Broadway and 42nd Street in midtown Manhattan and then went through Philadelphia, through Pittsburgh, and through South Bend, Indiana. But when it got to the Illinois border, the LHA created what may have been the first urban bypass in the nation by routing it around the congestion of downtown Chicago to Geneva where, once again, it went through the business districts of towns farther west in Illinois, then Iowa, Nebraska, and so forth. But the association's leaders also knew that many people would want to see Chicago and so they designated three feeder routes that connected the trunk line of the LH to downtown Chicago. They were set up so that the traveler or shipper could enter the city from one end and leave it from the other.

The Indiana feeder route was another "named highway" called Adeway. Adeway connected Chicago with Indianapolis and crossed the LH at Dyer, Indiana, the town west of Schererville. One of the Illinois feeder routes was the Dixie Highway, known locally as Vincennes Trail or Chicago Road. It connected Chicago with Miami, Florida, via Chicago Heights. The second Illinois feeder was Roosevelt Road, which had traditionally connected Chicago with Geneva. Eastbound or westbound, the traveler had a convenient way in and out of Chicago since all three of the feeders met at Michigan Avenue and Jackson Boulevard a few blocks south of the Art Institute of Chicago.

In theory and on maps, the LH system appears pretty simple. But in practice, it took a transcontinental string of people to see to it that the routes were signed, that the road was paved, that it was straightened when necessary, and that the highway brought as much business as possible to their respective towns. These local officials were known as "consuls." Nearly each highway town and county in the 12, and later 13, LH states had one. In its heyday, the LHA, all told, had 262 consuls. The local consul was also in charge of his town's "control." This was the place—a hotel, a shop, the post office—from which mileage to the next control was measured. It was also often the place that dispensed tourist information.

Not long after it was organized, the LHA decided that the association would not actually build the highway. Instead it would set about educating the American public as to the value of improved roads. The consuls became a key part of this plan. In each state, they identified areas that would benefit from "seedling miles," while the association board members coordinated donations of road-building materials with local funding and state engineering and supervision. The seedling miles, little stretches of concrete, were typically laid down on the highway in the middle of nowhere, so that country people could get an idea of how much better their lives would be if they could move themselves and their produce on improved roads instead of struggling through the dust and mud. The stretch of the highway around Chicago did not just get a seedling mile, however. It hosted the ultimate seedling mile, the Ideal Section. Between 1921 and 1923, the Ideal Section was constructed in Lake County, Indiana, between Schererville and Dyer. Here civil engineers and landscape architects from all over the country applied the best of their knowledge and experience to create the most advanced roadwork known at the time.

Once World War I had ended, American tourists wasted no time hitting the road. In the early 1920s, they tried camping, and LH towns soon offered them campsites with amenities like drinkable water and fireplaces, as well as convenience stores. Creative business people along the highway quickly developed "Lincoln Highway" cafés or transformed their livery stables into "Lincolnway" gasoline stations. Housewives turned spare bedrooms into "Lincolnway" tourist homes, and these were followed by tourist courts with rows of cabins that could be rented by the night.

The LH did not spring into life without parents, however. The highway around Chicago was preceded not only by ancient footpaths and wagon tracks but also by railroads. In the years preceding the inception of the highway, an adventurous traveler from Schererville could have hopped on the Elgin, Joliet and Eastern Railway, ridden it to Chicago Heights, then transferred to the Joliet and Eastern interurban, changed to the Aurora and Plainfield in Joliet, then to the Chicago, Aurora and Elgin in Aurora for the final leg to Geneva. It is hard to say how long such a journey would have taken, but it could have been made. After World War II, as Chicagoans began moving to the suburbs in droves, sleepy little towns on the highway around Chicago began to awaken with new houses and new people. Subdivisions soon covered the ground between their downtowns and the highway. Once again, the highway connected local residents' homes with the railroads. This time, they were commuting to Chicago from places like New Lenox or Batavia on any one of the several great railroad trunk lines radiating from Chicago and crossing the LH.

Still, it was expected by the late 1950s that the new and improved superhighways would ring the death knell for the LH, but that was not the case. The LH around Chicago could do what the fast-paced, limited-access roads like Interstate 80 or Interstate 55 could not: it took people to and from suburban workplaces and shopping and entertainment venues that held no interest for cross-country travelers. Likewise, highway motels continued to do good business because salesmen still needed places to stay overnight as they worked their districts, and the motels also provided temporary housing for young families waiting for their new houses to be finished.

Meanwhile, the physical road kept changing. Most of it around Chicago had been paved with concrete or macadam by the very early 1920s. But before and even after that, the route and alignments had changed many times. By the time the LHA disbanded in 1927, the federal government was preparing to remove the names from all the cross-country highways and replace

them with numbers. This action begat the "second generation" highway called Route 30. Then, in the late 1950s, as the interstate system became more sophisticated, even the bypass was bypassed. By the 1970s, the LH around Chicago had seen its best days. In most areas, it was still two lanes wide. Traffic congestion was mounting. When state and federal money became available, resurfacing and reconstruction began, nearly obliterating not only the original pavement but also the notion of a LH. Then something unexpected happened.

In 1992, the LHA was revived. Within a year, all the original LH states had formed chapters with the intention of preserving the history of the highway. Members of the Indiana and Illinois chapters started by painting the LH logo on utility poles. Then Illinois tourism people got into the act by creating the Illinois Lincoln Highway Coalition. Working together, these groups created a new LH entity: the LH as a destination. Not only was the LH around Chicago still a viable transportation corridor, it was also an opportunity to experience transportation history.

"A journey over the Lincoln Highway," wrote Frank H. Trego in 1913, "is an education in itself." Early LH tourists learned this firsthand while they sampled the easy-going nature of midwestern geography as it combined farms and cities in its course around Chicago. In general, the original LH paralleled Lake Michigan at a varying radius of 30–40 miles. The "tour" that follows in this book covers the counties of Lake in Indiana and Cook, Will, and Kane in Illinois. The "original route" towns are Schererville and Dyer in Lake County; Sauk Village, South Chicago Heights, Chicago Heights, Olympia Fields, Park Forest, and Matteson in Cook County; Frankfort, New Lenox, Joliet, Plainfield, and Wheatland Township in Will County; and Aurora, North Aurora, Batavia, and Geneva in Kane County. Second-generation towns are Lynwood and Ford Heights in Cook County, Oswego and Montgomery in Kane County, and a bit of Kendall County. Nearby towns that grew out to the LH in the late 20th century were Mokena, Crest Hill, Oswego, and Montgomery.

In Schererville and Dyer, the traveler on the original route of the LH, also known as the Sauk Trail and Joliet Street, was struck by the pronounced, sandy slopes on either side of the road. These had once been the beach of an ancient Lake Michigan. The westbound road out of town curved gently back and forth as it crossed ditches that were dug to drain the marshes in between the slopes or dunes. West of Dyer, the traveler was again surrounded by farm fields until crossing the Illinois line. Thereafter the LH traversed woods and marshlands beyond which were dairy farms and the little towns of Strassburg and South Chicago Heights. In the first months of its existence, the LH intersected Vincennes Trail and then continued west on the Sauk Trail through Richton Park and into Frankfort before veering north to a junction with State Road in Will County. That route lasted only through the winter of 1913–1914. By April, the LH had been rerouted north from the intersection with Vincennes Trail into Chicago Heights with its many garages, hotels, cafés, shops, parks, and theaters. At the north end of Chicago Heights, the highway turned west on Fourteenth Street, leaving travelers with memories of tree-lined streets, substantial houses, and parks as they motored back into the country. Farms stretched over broad hills to the horizon, and the LH ran straight and true down a section line as it passed a few rods south of the exclusive Olympia Fields Country Club and farther on, six blocks north of a little market town called Matteson—a clump of trees and a church spire the only indication of a thriving village from that perspective. Within five miles, the LH had crossed into Will County, and the road became curvy and narrow as it traversed ravines and thickets in the neighborhood of Hickory Creek and its low-level continental divide. Off to the south was the village of Frankfort, where the Sauk Trail met State Road and again became the LH as it approached New Lenox. The terrain was broadly curved as the traveler crossed Hickory Creek and the road became known as Cass Street.

Suddenly car and driver were sharing the roadbed with the steel rails of the interurban. Houses were closer together, mixed with cemeteries and commercial establishments. There were cafés, tourist homes, and public parks too. The grade became steeper as the highway approached the bluffs of the Des Plaines River in downtown Joliet. There it crossed the river and the remains of the Illinois and Michigan Canal, made a right onto Western Avenue, and swept through a

neighborhood of substantial houses and a women's college. In no time, the mansions were in the rearview mirror and the highway was angling cross-country past Six Corners to Plainfield less than 10 miles away. Plainfield was a compact little town, with New England–style houses and churches. West of its business district, on the other side of the DuPage River, the highway turned north into a classic LH cross-country stair-step route through the broad-hilled prairie farmland of Wheatland Township.

The final step delivered the traveler onto Ohio Avenue on the southern outskirts of Aurora in Kane County. As the traveler left the campgrounds, the roadhouses, and the working-class neighborhoods behind, he may have been surprised to find that the commercial center of the "City of Lights" was located on islands in the middle of the Fox River.

Once across the river, it was a different world. Gone were the rolling, open prairies. Now the highway headed north through woods along the bluffs on the west side of the river. Mostly it was a mix of pastureland and roadside establishments in North Aurora, but the Central States Exposition Park was also located there, on the east side of the highway. The children's town of Mooseheart followed on the west side, and the road felt narrower as it was hemmed in by trees and brush and the trolley tracks. After passing the gates to Mooseheart, it entered the "big woods" of Batavia. Although there was some commercial development on the highway, it essentially bypassed downtown Batavia as it had done in North Aurora. From the highway, tourists would have noted a cemetery and the road to the local quarry along with some impressive houses and grounds. From the woods north of Batavia, the highway approached Geneva on First Street. Here the countryside was more open and spread out in feeling. The highway felt much wider too, running on First Street, and later on Third Street, in town, then turning onto State Street.

Eventually this broad avenue, the LH, veered southwest onto Kaneville Road, and the tourist left the cities and farms of eastern Illinois. Now he found himself back on the prairie, looking forward to the Mississippi River and the wonders of the West.

One

THE ORIGINAL ROUTE

The Lincoln Highway Association (LHA) was conceived by Carl G. Fisher, but it was operated by men involved in automobile manufacturing on a day-to-day basis. They saw that the stretches of the Lincoln Highway (LH) that connected the big towns of Chicago Heights, Joliet, and Aurora south and west of Chicago were maintained fairly well but were still only dragged-earth tracks, sometimes topped with gravel, through weeds over terrain that ranged from sand dunes to marshes to rolling prairies and impressive river bluffs. The job of the leaders of the LHA was to encourage the upgrading of these roads so that they would allow cross-country travel at any time of the year in any weather. To achieve this purpose, they recruited "consuls" from each community on the highway. As elsewhere in the nation, Indiana and Illinois each had state and county consuls too. In Illinois, there were also regional consuls and a Chicago consul. The mission of the consuls was to care for the road and to promote it. They worked for the LHA principles but also for the betterment of their local communities. The consuls came from assorted walks of life: newspaper editors, automobile assemblers, purveyors of stationery, and bankers, just to name a few. Some took the responsibility for a year or two. Others remained the local consul long after the association officially disbanded in 1927. Some were dedicated solely to the LH, while others were real road enthusiasts, belonging to whatever named-road organizations applied to their location. It was up to the association's field secretary, Henry C. Ostermann, to glue their efforts together.

In the days of dirt roads, driving conditions were unpredictable, especially in the "mud states" of Indiana, Illinois, and Iowa. Roads were dusty in summer, rutted and icy in the winter. With no pavement, gutters, or sewers, the Sauk Trail, seen here near Schererville, collected and held water from a hard rain or a sudden thaw until it evaporated or sank into the sand to become mud. (Courtesy of LHA collection/University of Michigan.)

On the Kalvelage farm, near Sauk Village, the future LH was in no better shape. *Illinois Highways* magazine reported in July 1914 that there were 85,000 miles of dragged-earth roads in Illinois. Outside the big cities, the entire length of the LH was bare dirt or graveled road. Eighty years later, these farm fields, east of Torrence Avenue, were replaced by a grocery store and parking lot. (Courtesy of Schererville Historical Society.)

Indiana native Carl G. Fisher made his fortune in automobile headlamps. He was known as a promoter of bicycles and cars who was not above using crazy stunts to attract attention. He once pushed a seven-passenger car from a rooftop in Indianapolis just to show it could be driven afterward. In 1909, he cofounded the Indianapolis Motor Speedway Company as a proving ground for automobile manufacturers to test their latest designs. With his fame and fortune made by 1912, Fisher was in a position to solve the automobile industry's biggest problem: terrible roads with nearly useless directional signs. In September, he invited automobile executives to a dinner in Indianapolis during which he proposed they build a coast-to-coast rock highway "before we're too old to enjoy it!" Within a year, the LHA was organized in Detroit. Henry B. Joy was named president and Fisher the vice president. In 1915, Fisher created the Dixie Highway, which spanned the continent from Michigan to Florida. (Courtesy of LHA collection/University of Michigan.)

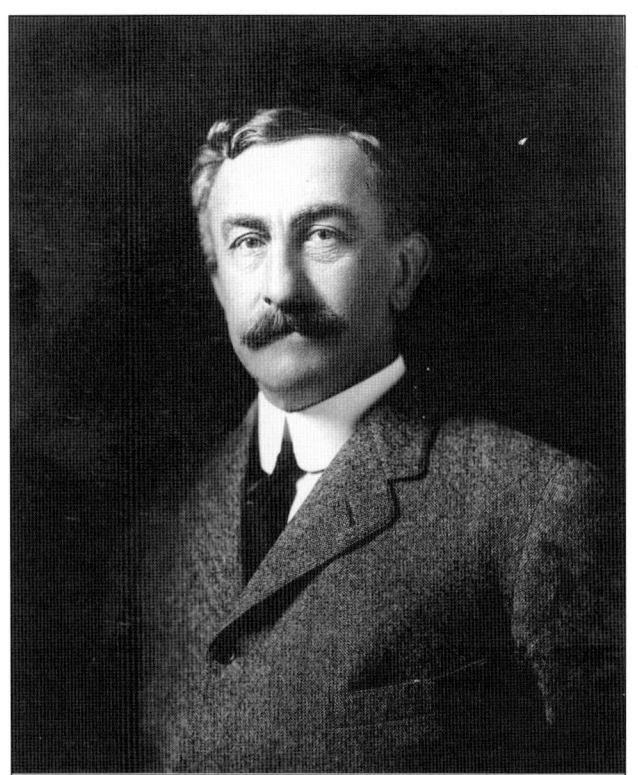

As president of the Packard Motor Car Company, Henry B. Joy had made many test drives across the country by car. Having firsthand knowledge of miserable road conditions, he led the LHA in creating a strategy to educate the American public about durable, all-weather roads. Instead of building the "rock highway," the LHA taught Americans to demand and expect this type of road construction from their state and federal governments. (Courtesy of LHA collection/University of Michigan.)

Joy also convinced Carl G. Fisher and others to name the highway for Abraham Lincoln. As a means of promoting the highway, LHA membership certificates were sold through automobile dealerships and good roads enthusiasts all over the country. For $5, anyone could join and support the association's plans. Pres. Woodrow Wilson was issued certificate No. 1. Herman Koehler, who bought the certificate shown above, operated Koehler's Union House, a Chicago Heights hotel. (Courtesy of Chicago Heights Public Library.)

As LHA field secretary, Henry C. Ostermann tried to touch base with every consul in all 12 states—in person—at least twice a year. That meant about 500 visits and an average of 15,000 miles a year in the Packard touring car provided by Joy's company. Driving the "official marking car," Ostermann was part of the inspection party that came out from Joliet to Frankfort in April 1914 to make the decision between the Sauk Trail and Fourteenth Street for the LH through south Cook County. Noting that the inspection had been made in record time, a reporter wrote that "when asked what constituted a road test, Mr. Ostermann stated that, 'the clearest view of a road's advantage to the tourist could be gained by high-speed travel over the route. . . . The north route [Fourteenth Street] . . . had . . . a distinct advantage in that it had but one unprotected [railroad] crossing as against three on the south route.'" (Courtesy of LHA collection/University of Michigan.)

August W. Stommel became the consul for Lake County in 1914. A resident of Dyer since the 1860s, he opened his Cheap Store on the southwest corner of the LH and Adeway in 1877. There he sold everything from "rats to ranches" or muskrats to real estate. In 1903, he founded the First National Bank of Dyer on the northwest corner with William J. Gettler and other local businessmen. (Courtesy of Dyer Historical Society.)

Stommel would have been familiar with these 25-foot dunes on the south side (right) of the Sauk Trail or Joliet Street, as it was known in Schererville. They were remnants of a former Lake Michigan beach. Although much of the sand was sold off for landfill, enough remains between Schererville and Dyer to give today's traveler an idea of the terrain covered by the early LH. (Courtesy of Schererville Historical Society.)

Orrin Fitch (right) and his brother Albert operated the Dyer Garage, which included the first Ford agency in Lake County. There the brothers assembled and sold Ford and CASE automobiles. Their business was located on the LH a block west of Adeway, now known as Hart Street, and west of Stommel's Cheap Store. Orrin Fitch became the local LHA consul in 1924. (Courtesy of Dyer Historical Society.)

After contractor Herman Teutemacher installed the cross on top of Dyer's St. Joseph's Church in 1903, he took photographs of the surrounding countryside from the steeple. Here one sees where the future LH crossed Plum Creek beyond the barn on the right at the curve in the road. Fields, houses, and woodlots mingled in the stretch between Schererville and Dyer. Fitch's dealership was in the distance on the left. (Courtesy of Dyer Historical Society.)

Just over the Illinois line and still on the Sauk Trail were the farms and village of Strassburg. The bridge above was known as the Kalvelage bridge, named for the family whose farm the trail cut through. When the LH was new, motorists shared the bridge with local livestock when the water in the Lincoln-Lansing Ditch was high. In 1957, Strassburg was incorporated as Sauk Village. (Courtesy Nancy L. McConathy Public Library/Irene Kalvelage collection.)

Farther west, the original route of the LH reached the Burgel Tavern at Brown's Corners in South Chicago Heights. There it left the Sauk Trail and ran north on the Vincennes Trail or Chicago Road to Fourteenth Street in Chicago Heights. In 1915, this stretch of the LH also became part of the Dixie Highway—Carl G. Fisher's second cross-country highway. (Author's collection.)

William G. Edens played an important role not only in the LH story but also in the development of the Illinois and interstate freeway systems. For that he is known as "the father of the Illinois Good Roads movement," even though he never owned or drove a car. Named the LHA's Chicago consul in 1916, he later served as the Cook County consul. Before becoming the chairman of the good roads committee of the Illinois Bankers Association, he had been a national officer of the Brotherhood of Railroad Trainmen. Edens also headed the Illinois Highway Improvement Association (IHIA), which had been organized at Peoria in 1912. Both groups were successful in convincing Gov. Edward F. Dunne to sign the bill that switched responsibility for the state's main routes from the townships to the counties. In 1918, Edens led the IHIA lobby of the state legislature to issue $60 million in bonds to improve Illinois highways. The Edens Expressway, northwest of Chicago, was named for him in 1951. (Courtesy of LHA collection/University of Michigan.)

A colleague of William G. Edens, Ralph McEldowney was the treasurer of the IHIA and the first consul for Chicago Heights. He also served on the survey team for the Chicago Heights Good Roads Day committee and joined other members of the Chicago Heights Automobile Association when they met with the LHA inspection party in Frankfort. (Courtesy LHA collection/University of Michigan.)

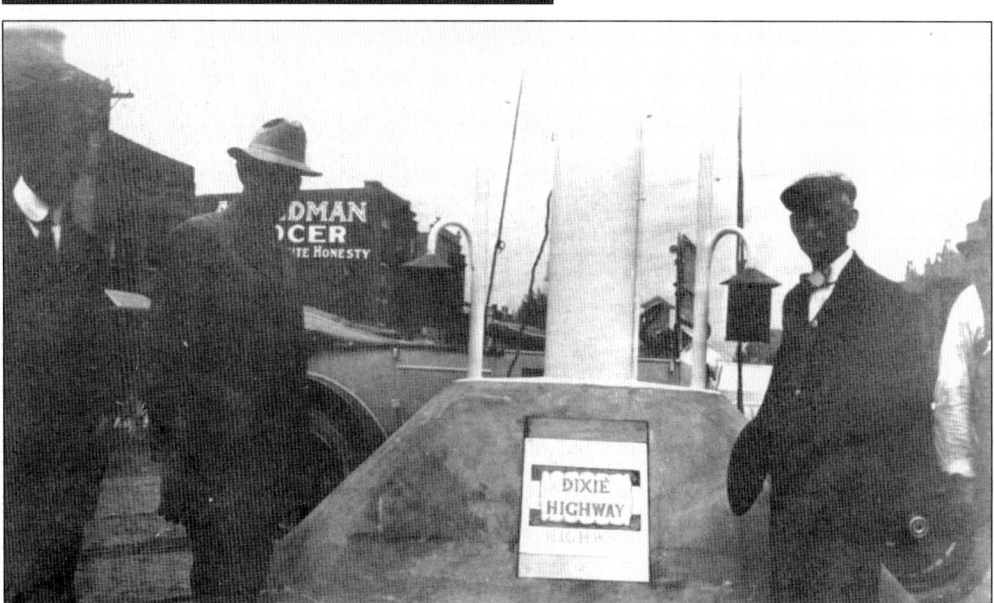

Benjamin H. Vannatta, on the right, a Chicago Heights druggist, later replaced McEldowney as the local consul. Vannatta also served on the Bloom Township highway commission. Vannatta advertised his drugstore at 6 Illinois Street in the 1915 LHA road guide as the place to stop for tourist information. This photograph was taken at the intersection of Illinois Street with the LH and the Dixie Highway. Henry C. Ostermann is on the left. (Courtesy of LHA collection/University of Michigan.)

Although streets in downtown Chicago Heights were paved with brick, the country roads were not. On Illinois Good Roads Day, April 15, 1914, Joseph Klein (standing on his drag) and his eight sons raced with others to spread about 100 loads of stone on the LH south to Brown's Corners and west to Western Avenue. William G. Edens was in the crowd and may have awarded the prizes to contest winners. (Courtesy of Chicago Heights Public Library.)

Henry C. Ostermann is standing on the 1916 McEldowney bridge westbound on the LH over Thorn Creek in Chicago Heights. Among the Bloom Township highway commissioners noted on the granite cornerstone was Benjamin H. Vannatta. The separated and protected pedestrian walkways and concrete lanterns were welcome innovations. Both imply that traffic was becoming heavier and faster. Below the cornerstone is the red, white, and blue LH insignia. (Courtesy of LHA collection/University of Michigan.)

Going east on the LH on the north side of Matteson is the LHA Packard. To signal the official designation of the route in April 1914, the "trailblazer car" was driven coast to coast by Henry C. Ostermann. The unguarded Illinois Central Railroad crossing that he referred to in his summation of reasons for choosing the northern route through Rich Township was a few blocks beyond this hill. (Courtesy of Ruth Frantz.)

The Olympia Fields Country Club opened on the north side of the LH, east of the Illinois Central tracks, in 1915. This foursome and caddies are on the fourth tee of the Second Course, which was closest to the LH. While Butterfield Creek and other natural hazards added interest to play, the club also planted domesticated lilac bushes along the LH from the Illinois Central tracks east to Western Avenue. (Courtesy of Olympia Fields Country Club.)

There were no local consuls for Matteson, Frankfort, or New Lenox. Before it became the LH, locals referred to the road between Frankfort and New Lenox as State Road or State Highway. This 1915 photograph shows an unimproved stretch near Frankfort. Some also recalled that it could take four horses to pull a load of milk down a muddy farm road to the train depot. (Courtesy of LHA collection/University of Michigan.)

Real estate attorney William A. Murphy was the Joliet consul in the 1920s while Theodore R. Gerlach served as the consul for Will County. Gerlach was the vice president of Gerlach-Barklow Company, publishers of art calendars and other printed matter. Here Henry B. Joy and Austin Bement are getting ready to attempt a muddy stretch outside Joliet, about 35 miles southwest of Chicago. (Courtesy of LHA collection/University of Michigan.)

The LH might not have come to Plainfield if it had not been for the enthusiastic owner and editor of the *Enterprise*, U. S. G. Blakely. Besides writing countless editorials in favor of concrete roads in Illinois, he was the local consul for 26 years and is said to have added a porch to the front of his house on the LH so he could keep track of the tourists. (Courtesy of LHA collection/University of Michigan.)

In 1913, Plainfield was a small farm town with a big heart. Dragged-earth roads connected it to Aurora and Joliet. Plainfield paved its portion of the highway in 1921 and named it Lincolnway. The Ralph H. Newkirk Construction Company of Joliet ran the project. Looking back, it was widely agreed that Plainfield had done more to promote the LH in proportion to its population than any other community in Illinois. (Courtesy of LHA collection/University of Michigan.)

Northwest of Plainfield was Aurora, "the City of Lights," in Kane County. The first local consul, Robert C. Horr, was elected in December 1913. Horr was then the superintendent of streets and president of the Aurora Automobile Club, an affiliate of the AAA and the Illinois State Automobile Association. He was later replaced by James Lino, news editor of Aurora's *Beacon-News*. (Courtesy of LHA collection/University of Michigan.)

M. K. Guyton of Aurora became the Kane County consul in 1916. He also served as the Aurora District chairman of the Canon Ball Trail Association. Guyton made his living as an accountant and actuary for Yeoman of America and was also secretary of the Aurora Automobile Club and its bylaws committee. (Courtesy of LHA collection/University of Michigan.)

Also a Canon Ball Trail booster, William H. McCullouch was a principal in the firm of Finch and McCullouch, printers, binders, and publishers. As the LHA eastern Illinois state consul, McCullouch was very involved in route changes south of Aurora and west of Geneva. He also served as the president of the Aurora Automobile Club. McCullouch was given credit for the improvement of the LH as well as all the other highways in the area. (Courtesy of LHA collection/University of Michigan.)

This postcard view of bustling Aurora shows the LH running on Fox Street, which later became Downer Street. Aurora businesses produced belt conveyors, excavation equipment, pumps, office supplies, and even balloons. After crossing the Fox River, the LH turned north toward North Aurora and the heavily wooded Fox River valley. From there to Geneva, the LH was also known as the Aurora-Elgin Highway and State-Aid Route 1. (Author's collection/V. O. Hammon Publishing Company.)

The Loyal Order of the Moose created its worldwide headquarters and vocational school and home for dependent children in 1913 at Mooseheart on the LH. Mooseheart's consul, Rodney Brandon, was also the school's superintendent. An Indiana native, Brandon had worked in newspapers and insurance before becoming the supreme secretary of the Moose—the man in charge of keeping it organized and paying its bills. (Courtesy of LHA collection/University of Michigan.)

In 1912, the Moose purchased the Brookline farm—its buildings are shown here—and the Van Nortwick farm. By 1914, approximately 60 boys and girls were living at Mooseheart, all of them offspring of deceased members of the Moose. Brandon and his wife, Harriette, lived in the farmhouse and from there supervised the creation of the town as well as the academic and vocational training of the children. (Author's collection.)

On Good Roads Day, April 15, 1914, Rodney Brandon and William G. Edens joined Gov. Edward F. Dunne to commence the improvement of a one-mile section of the road in front of Mooseheart. In the interest of "pulling Illinois out of the mud," the governor used a ceremonial shovel to start work on the first state-aid road in Illinois and the first paved link of the rural Illinois portion of the LH. (Courtesy of Ruth Frantz.)

Most of the attendees probably arrived on the Chicago, Aurora and Elgin (CA&E) electric interurban, which ran on the same alignment as the LH between Aurora and Geneva. Lunch was served to the crew of about 200 shovelers and 40 teams. At the end of the day, it was calculated they had removed 130 cubic yards of soil and left behind a subgrade that was a "draftsman's dream." (Courtesy of Ruth Frantz.)

The CA&E interurban (note the trolley tracks in the grass on the right) ran cars every half hour between Aurora and Batavia through North Aurora. In May 1914, the North Aurora village board changed the name of the Aurora-Batavia Road/Aurora-Elgin Road/River Road to Lincoln Road and also granted permission to the CA&E to run on the LH for another 20 years. (Courtesy of LHA collection/University of Michigan.)

Cornelius C. Collins, a building contractor and former mayor of Batavia, served as Batavia's first consul. He was followed by W. H. Reaney, the CA&E depot agent and president of the Batavia Businessmen's Association. Robert Hollister came next. The local undertaker, Hollister also served on the Kane County board of supervisors and as the Batavia Township food administrator during World War I. This scene is at First Street and the LH. (Courtesy of Batavia Historical Society.)

The CA&E continued north on the LH into Geneva, veering west onto Third Street and then north to State Street (LH) where it doglegged onto Anderson Boulevard. At the left side of the photograph is a painted LH signpost. The livery owned by consul Albert E. McIntosh, also a Kane County supervisor, was on State Street. In 1916, McIntosh succeeded Edward Bradley as consul. (Courtesy of Ruth Frantz/H. B. Brooks Photo.)

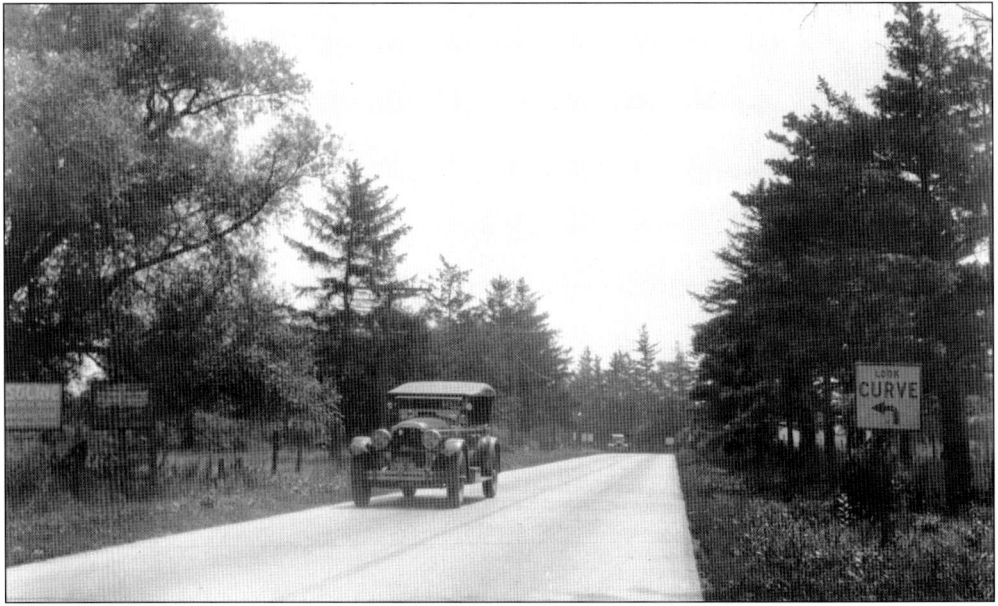

Oscar Nelson, a Geneva banker and mayor, was his city's last consul. His offices were located on the corner of the LH and Third Street. Nelson organized Geneva's home defense during World War I and later served as the Illinois state treasurer. The west side of Geneva was the end of the line for the LH around Chicago. In 1922, the route of the LH was moved from Keslinger Road to Route 38. (Courtesy of LHA collection/University of Michigan.)

Two

The Roadway de Luxe

By 1920, the association's mission to create a market for and a desire for excellent roads in the minds of the American public had been achieved. It had already blitzed the country with publicity campaigns. It had appointed local people, the consuls, to whip up enthusiasm on a day-to-day basis. They had organized committees of cement manufacturers, fund-raisers, and state highway commissioners to produce seedling miles here and there. Now they decided what was needed was not only the basic all-weather, hard-surface road but the concept of what roads could be like when they were designed properly for safety, efficiency, and beauty. The next project would be the "roadway de luxe," better known as the Ideal Section.

Austin Bement was vice president and secretary of the LHA in 1920. He was a financial and administrative genius as well as a man of action, having driven the LH coast to coast with Henry B. Joy, changing tires and pushing cars out of the mud along the way. He organized and chaired the Ideal Section Technical Committee and worked with Henry C. Ostermann to determine the best location for the prototype stretch. It had to be central and accessible, eligible for federal money, and wide enough for four lanes and shoulders. The site between Dyer and Schererville in Lake County, Indiana, was almost official before Ostermann's untimely death in June 1920. Bement focused the resources and energies of the LHA, the federal government, the state of Indiana, Lake County, and the United States Rubber Company on building the best stretch of road in the nation. (Courtesy of LHA collection/University of Michigan.)

Bill Gettler, age 19 when this photograph was taken, was an Ideal Section water boy who lugged a six-gallon bucket of water around to crew members who drank from a tin cup. He also kept his new Kodak camera handy and took many of the images used in this chapter. In this photograph, he is driving the Kish Garage entry in a race in Hobart, Indiana, in September 1920. (Courtesy of Gettler collection/Dyer Historical Society.)

This is an artist's concept of what the Ideal Section would look like—a straight and true reinforced concrete road that could be driven safely at night in any kind of weather by truckers as well as motorists. Its wide shoulders and pavement would be protected with guardrails and directional signs. A submerged drainage system and underground wiring for electric lights would enhance the beauty of its professionally landscaped right-of-way. (Courtesy of LHA collection/University of Michigan.)

They began with the relatively unimproved stretch of sand and hills between Schererville and Dyer with privately owned farms and woodlots on either side. The contract between the LHA and the State of Indiana provided that the state would pledge $33,000 and Lake County would contribute $25,000. The federal government later added $20,000 and the United States Rubber Company donated $110,000. (Courtesy of LHA collection/University of Michigan.)

This was uptown Dyer in September 1922 as the road crew prepared the subgrade with gravel. Signs on the lamppost in the center of the intersection instructed drivers to "Go Slow, Keep to Right." Also on the post were the logos for the LH and Adeway, plus directions and mileages to Hammond, Gary, and Lafayette, Indiana. There was no mention of how to detour around the construction. (Courtesy of Gettler collection/ Dyer Historical Society.)

Close to 14 miles of 18-foot-wide concrete roadbed were under construction that summer in Lake County east and west of the Ideal Section. To deliver materials to the site, a batch-car railway crossed the Monon Railroad right-of-way by tunneling beneath it. The present-day LH is only a few feet to the right of this ditch. (Courtesy of Gettler collection/Dyer Historical Society.)

Construction of a hard-surfaced highway was dependent at first upon the railroad. Gravel, cement, and reinforcing rods were delivered to Dyer on the Elgin, Joliet and Eastern Railway (EJ&E), which was also known as Chicago's "Outer Belt Line." Running from Gary, Indiana, to Waukegan, Illinois, the EJ&E paralleled the LH for most of the way around Chicago. Here a steam-powered clamshell bucket is feeding a batching plant at Teutemacher's Dyer Supply siding. (Courtesy of Gettler collection/Dyer Historical Society.)

The loaded batch cars were ferried by a steam locomotive called the *Burton* on the small-gauge rail line that had been laid from the EJ&E siding south on Adeway to the LH and east for the length of the construction site. Such means of moving bulk materials were in general use wherever road building took place. The prepared roadbed here has been graded and covered with a protective layer of straw. (Courtesy of Gettler collection/Dyer Historical Society.)

Here the *Burton* has positioned the batch cars near the paving machine. Holes in the sides of the boxes were used to attach the winch, which lifted the box over the paving machine as crew members spotted it over the hopper. Combined with the work done in 1922, by 1926 Lake County had a total of 758 miles of improved state and county roads. (Courtesy of Gettler collection/Dyer Historical Society.)

While the workers in the foreground secure a winch to the box prior to positioning it over the mixer, laborers in the background, left, work the concrete as it comes out of the mixer. Since there are no steel bars apparent in the graded roadbed, it must be assumed that this was not the Ideal Section being paved but the stretch of the highway west of it. (Courtesy of Gettler collection/Dyer Historical Society.)

Here the box, hanging from the winch, is guided by hand into position, or spotted, over the hopper, now lowered to receive materials with which to make concrete. Plans for the Ideal Section were titled "Federal Aid Project 32, Fiscal Year 1922, 'Ideal Section.'" In 1923, the state instituted a gasoline tax that helped to finance road construction to the tune of over $8 million in 1926. (Courtesy of Gettler collection/Dyer Historical Society.)

Once the materials and water were delivered to the site, the concrete was mixed and poured. This shot of the paving machine from the business end shows how concrete was distributed between the forms and hand labor was needed to do the screeding and final finishing. The concrete was then covered with wet straw and allowed to cure for 30 days. (Courtesy of Gettler collection/Dyer Historical Society.)

Horsepower of both kinds as well as manpower cleared and graded the Ideal Section roadbed to the proper elevation. Drawings showed a row of catalpa trees, open fields, brush, and dense woods on the north side of the Ideal Section (right). To the south were several houses, woodlots, and scattered trees. There were also 13 farm fields, including those belonging to August W. Stommel. (Courtesy of Gettler collection/Dyer Historical Society.)

The steamroller moved ahead of the mixer to smooth and compact the subsurface before the first layer of concrete was put down. One of the outstanding features of the Ideal Section was the use of steel reinforcing mats within the concrete layer. This increased the stability of the concrete and, thus, the longevity of the road. (Courtesy of Gettler collection/Dyer Historical Society.)

As the new surface took shape, Bill Gettler recalled that engineers from around the world came to take a look at it. "It was supposed to be the greatest road in the world," he recalled during an interview in 1995. The rebar that made the section famous is more obvious here. In the distance, automobiles, as though nipping at the heels of the paver, are already using the road. (Courtesy of Schererville Historical Society.)

Much of the terrain was on a downward incline, south to north, from sand dunes into the Plum Creek floodplain. The crew is seen here pumping a weak concrete slurry into the soil to reinforce it before constructing the retaining walls for the bridge. The same was done in constructing the culvert for the Schilling Ditch. (Courtesy of Gettler collection/ Dyer Historical Society.)

The Ideal Section crossed two streams: Dyer Ditch and Schilling Ditch. Each required a bridge. The State of Indiana was charged with maintaining the road, drainage system, and bridges once they were operational. State and federal funds also went to pay for the landscaping and lighting system, but it was assumed that local businesses could be relied upon to maintain the plantings and pay the electric bill thereafter. (Courtesy of LHA collection/University of Michigan.)

The completed Ideal Section bridge over Dyer Ditch is shown here. Above the concrete piers and deck, walls were created with dressed limestone. The limestone commemorated the abundance of this material in the Midwest. It was laid in horizontal courses that echoed the horizontality of the prairie. Both Joliet and Batavia were known for their limestone quarries. (Courtesy of LHA collection/University of Michigan.)

The culvert for the Schilling Ditch was also finished with dressed limestone. It was in the vicinity of these bridges that Fred Tapp, a son of one of the contractors and himself a roadwork supervisor, walked into the woods and committed suicide in October 1922. It was unclear, at the time, why he did this. (Courtesy of LHA collection/University of Michigan.)

Jens Jensen, the former chief landscape architect for Chicago's West Side parks system, was hired as the landscape architect for the Ideal Section. Jensen was and probably still is the best known of the prairie landscape architects. Between 1901 and 1902, while conducting a survey of the lands surrounding Chicago for the proposed Cook County Forest Preserve District, he photographed every natural area from Lake Forest to Hammond, Indiana. In Indiana, as the organizer of Friends of Our Native Landscape and president of the Prairie Club, he became known as the "Apostle of the Dunes" and promoted the establishment of the Indiana Dunes as a national park. Landscape designers like Jensen designed cultivated settings with plants that strongly featured horizontal branches or flower clusters that repeated the horizontality of the natural midwestern landscape. (Courtesy of LHA collection/University of Michigan.)

As part of his plan for the beautification of the Ideal Section, Jensen included a prototype rest stop, shown above. The limestone structure would have provided travelers with a gas station, store, and restrooms. Nearby was the site of the Ideal Campsite. This simple and convenient one-level architectural style was later used throughout the area and became known as the ranch house after World War II. (Courtesy of LHA collection/University of Michigan.)

The promise of Jensen's plans was embellished by local reporters. The Ideal Section was touted as the "road that will never wear out," and rumors were floated about the construction of a $1 million, 500-room hotel close by. A golf course was supposed to go along with it, and "many beautiful country homes" would appear along the highway in either direction. (Courtesy of Dyer Historical Society.)

Once the paving was finished, the landscapers went to work planting the trees and shrubbery that Jens Jensen envisioned as complementing the natural dune and prairie landscape of Lake County. He and others across the country tried to encourage the planting of native, low-maintenance greenery along the LH from coast to coast. In Illinois, the General Federation of Women's Clubs worked with other landscape architects to accomplish this. (Courtesy of LHA collection/University of Michigan.)

As a final touch, plans for the Ideal Section called for a memorial to the highway and to the section. Designed by Jensen, the little monument was built with local limestone and placed on the south side of the highway near the planned campsite property. The front plaque read, "The Ideal Section of the Lincoln Highway 1921." The back tablet commemorated the contributors to the project. (Courtesy of LHA collection/University of Michigan.)

In June 1923, the LHA announced that the Ideal Section was nearly complete and Austin Bement, inspecting the lamppost foundation and electrical connections above, commented that it was "justifying all our hopes and efforts." Earlier, representatives of all the financing, planning, and construction interests were joined at the site by engineers and other experts from around the country to inspect and accept the paving work. (Courtesy of LHA collection/University of Michigan.)

Once the paving was completed, lighting standards, guardrails, and new fences were installed. The telegraph and telephone companies had already moved their poles and wires back to the edge of the widened right-of-way, out of sight behind the trees. No sooner was the section opened to the public, though, than the expansion joints failed. The Hall brothers are shown here with air hammers breaking up the concrete. (Courtesy of Gettler collection/Dyer Historical Society.)

Another finishing detail was the installation of a billboard that described the Ideal Section as "a Model Stretch of Object Lesson Road built by the Lincoln Highway Association . . . with all the cooperation and financial aid" of the federal, state, and county governments along with monetary contributions by the United States Rubber Company. All the engineers, general contractors, public agencies, and other contributors were listed on the right-hand panel. (Courtesy of Dyer Historical Society.)

Bill Gettler recalled all the accidents that occurred at either end of the Ideal Section where the lanes narrowed because the Ideal Section was built four lanes wide, ironically to show how much safer that was, while the rest of the LH was only two lanes wide. This wreck ended up in front of the fire station in Dyer. (Courtesy of Gettler collection/Dyer Historical Society.)

By June 1923, most of the roadside plants were in bloom. Grass was springing up on the neatly graded shoulders. Onlookers were especially pleased with the look of the pedestrian pathway that wound through the trees on the south side of the road, providing not only a safe walkway in an area of heavy traffic but a beautiful view of native timber and grasses too. (Courtesy of LHA collection/University of Michigan.)

The completed Ideal Section, shown here now open to traffic, easily handled four lanes of trucks and cars. In its four-lane segment, the section was 1.3 miles long. An additional two-tenths of a mile comprised the tapering sections, which guided motorists back to two lanes. The Ideal Section's western end was a few feet west of the current intersection of Calumet Avenue and Route 30 in Dyer. (Courtesy of LHA collection/University of Michigan.)

For the first time, motorcars could move through rural Lake County safely at night—even if they did not have headlamps. For the Ideal Section, the General Electric Company provided Novalux street-lighting equipment mounted on concrete standards 35 feet high and placed every 250 feet on alternating sides of the road. The reflectors were arranged so that very little light fell beyond the pavement. Night lighting was the talk of the area, if not the entire country. Sadly, the Ideal Section, like so many other innovations and firsts, was lost in the hurly-burly of the Roaring Twenties. August W. Stommel commented in a 1939 newspaper interview that the native shrubbery had largely disappeared "because tourists wanted it for souvenirs." He added that the town of Dyer had refused to pay the electric bills, so the streetlamps were unused, although still standing. (Courtesy of LHA collection/University of Michigan.)

Three

IF YOU BUILD IT, THEY WILL COME

As someone once said, "It's a helluva lot easier to shuck a tourist than a bushel of corn." From Schererville to Geneva, from the smallest village to the largest city on the LH around Chicago, shrewd business owners figured out quickly how to capitalize on the ever-burgeoning stream of people on the go. The first thing was places to stay. Hotels increased and campsites were an innovation. Food and refreshment became available at any level of luxury from a hotel dining room to a roadside produce stand. The motorists also needed gas stations. And who were the travelers? Hikers, socialites, actresses, families, the military, and even an occasional airplane pilot used the road to get where they wanted to go. The LH route presented tourists with the personality and drama of the geography south and west of Chicago. It took tourists through town and countryside, up and down hills, around curves, over a continental divide, across creeks, rivers, ditches, and canals, and over, under, and alongside railroad tracks. They encountered farmers, housewives hanging laundry, garage mechanics, people who did not speak English, road crews, waitresses, schoolchildren, and shopkeepers. They saw prairies and farm fields, moraines and dunes, and woods and ravines, as well as grain elevators, barges, bridges, cattle, and churches. The first 25 years of the LH encompassed the exuberance of the 1920s and the economies of the 1930s. It was a time of refinement for the physical road as the nation learned about traffic safety and the federal government stepped in to provide the efficiency that the LHA had always craved: a straighter, faster, less-confusing track across the country. Most of the icons that are associated with the LH today were conceived in this period.

Among the first hikers on the LH were DeMers the Hobo Magician, the Lincoln Highway Kids, and Lawrence Henz of Chicago. The Lincoln Highway Kids (left) left Fort Wayne westbound on Easter Sunday in 1915, selling postcards along the way as a means of supporting themselves. Henz bet $3,000 he could walk from San Francisco to New York City surviving only on "the kindness of strangers." DeMers pushed a handcart to San Francisco. Just as ambitious, given his age, 97, was GAR veteran Johnny Ozier of Batavia (below). The first Batavian to walk to the city hall in Aurora on the LH, he made history on October 8, 1915, in about two hours. Among the more famous tourists were columnist Emily Post; the Van Buren sisters, who roared through on motorcycles; and movie actress Anita King, who drove the LH solo in 1915. (Left, author's collection; below, courtesy of Batavia Historical Society.)

The U.S. Army convoy of 65 motorized vehicles led by Henry C. Ostermann from Washington, D.C., to the West Coast via the LH arrived in Dyer on July 20, 1919. Officers, including future president Dwight D. Eisenhower, re-formed the line of trucks alongside the Dyer Bank. Lake and Cook County consuls and other local officials had escorted the convoy from Valparaiso, Indiana, to Dyer and then to Chicago Heights. (Courtesy of Dyer Historical Society.)

Through downtown Chicago Heights, the convoy, now led by the Goodyear Band, paraded to its camp on the west side of Thorn Creek at Sixteenth Street south of Mary McEldowney Park. The weekend was filled with dinners, parties, swimming, and a band concert from the balcony of the Victoria Hotel. On Monday morning, the convoy rolled on, had lunch in Aurora's Lincoln Park, and camped that night in DeKalb. (Courtesy Chicago Heights Public Library/Photoview by P. L. Huckins.)

Among the civilian population, some golfers arrived at the Olympia Fields Country Club via the LH, while others used airplanes. In 1923, the club hosted pilot-golfers from around the Midwest who flew in, landed on one course, played 18 holes on another, then flew home before dark. The world-famous Fourth Course opened in 1923, and club membership topped 1,000 by the late 1920s. (Courtesy of Olympia Fields Country Club.)

In 1926, in a small grove of trees between the Ideal Section memorial and a dune, a limestone bench designed by Jens Jensen was installed. The inscription read, "In memory of Henry C. Ostermann Vice President and Field Secretary of the Lincoln Highway Association, killed on the Highway in Iowa, June 8, 1920." (Courtesy of LHA collection/University of Michigan.)

Tourism boomed on the highway in the 1920s. This aerial shows the first feeder route that offered the east-to-west tourist an opportunity to detour to Chicago. Northbound Adeway (at left), another of the named highways of the early 20th century, crossed the LH in uptown Dyer on its way to Chicago from Lafayette and downstate Indiana. Adeway was locally known as Hart Street. (Courtesy of Dyer Historical Society.)

The Dixie Highway, a cross-country route in its own right, became an official LH feeder route in 1915. Here it is shown in downtown Chicago Heights where it used the same alignment as the LH. Standing at the intersection of Illinois Street and the LH are Henry C. Ostermann, third from the left, and Benjamin H. Vannatta, second from the right. The white LHA Packard touring car is behind them. (Courtesy of LHA collection/University of Michigan.)

53

East of Geneva, the designated feeder route was Roosevelt Road, which became State Street in Geneva. Roosevelt Road had long been Geneva's main connection with Chicago, offering that city's wealthier residents convenient access to their country estates as well as to Geneva's fine shopping district on Third Street. In August 1919, the north–south route of the LH through Geneva was changed from First to Third Street. (Courtesy of LHA collection/University of Michigan.)

No matter which feeder route the traveler chose, the terminal was the same: Michigan Avenue and Jackson Boulevard, a few hundred yards south of where these young ladies are standing in front of the Art Institute of Chicago. Travelers broke their journeys at some of the finest hotels and restaurants in the country, while a mile or two farther south they viewed the latest in automobiles on Chicago's "Motor Row." (Author's collection.)

Less sophisticated than a Michigan Avenue restaurant but no doubt just as welcome to the hungry traveler was the Thiel family's Lincoln Highway Refreshment Stand in Schererville. Hot dogs were cooked in the summer kitchen of the family home. From left to right are Eddie Schweitzer, Cecilia Smith, Agnes Seberger, and Gertrude Homan. The lunch stand, which also sold candy, tobacco, and ice cream, was next door to the Thiel garage. (Courtesy of Schererville Historical Society.)

Sandwiches and fried chicken were available at Teibel's starting in 1929. The 12-seat diner, at the intersection of LH and U.S. 41, became known as "the Ideal Family Restaurant." The brothers Martin and Stephen Teibel once owned all four corners at this intersection, which is sometimes called the "crossroads of the nation." Twelve years later, the Sauzer family opened a waffle shop on the southeast corner. (Courtesy of Schererville Historical Society.)

Roadside stands on the LH offered fresh fruit, vegetables, and cider to travelers. When builder-contractor Herman Teutemacher retired, he set up an apiary on his wife's farm in Dyer. It was the largest in Indiana and a model for other beekeepers. In good weather, he sold the honey and honeycombs from a table he set up in front of his house on the LH across from St. Joseph's Church. (Courtesy of Schererville Historical Society.)

Having purchased local produce for supper, many tourists found a convenient campground that included a laundry at Pilcher Park, about a mile east of Joliet. Pilcher's arboretum had been created by Harlow N. Higginbothom, who called it "the Forest of Arden." He sold it to Robert Pilcher, who donated it to the City of Joliet in 1922. It was estimated that in 1923, nine thousand people camped on the five-acre site. (Courtesy of Will County Historical Society/E. C. Kropp Company postcard.)

If they had continued on to Plainfield, they may have camped at Electric Park, opened in 1904 by the Aurora, Plainfield and Joliet Railroad as an attraction for interurban riders. The main entrance was at James Street on the LH. Rental cottages and campgrounds were at the southeast corner of the park. Plainfield also offered a 30-bed hotel and a free municipal campground with gas and water hookups. (Courtesy of William Molony/Curt Teich postcard.)

It is estimated that between 1920 and 1924 there were 5,000 municipal camps across the country. This is Phillips Park on the southeast side of Aurora. It was built by the Aurora Automobile Club in 1923 and provided campers a shelter with two fireplaces and ovens, as well as a sink and well water. The club also operated a campground on the LH north of town on the Fox River. (Author's collection.)

The Fox River valley was a favorite camping area. Between Aurora and Geneva, there were 10 miles of woods interspersed with good views of the bluffs and river beckoning to the LH traveler. The site above was located in North Aurora. That is the LH Packard "posing" in front of the camp store. (Courtesy of LHA collection/University of Michigan.)

It did not take long before cross-country travelers tired of roughing it, which was one of the reasons the Ideal Campsite was never built. But even those who enjoyed camping often spent the odd night in a motel with a shower and ready-made bed. By the mid-1930s, Teibel's had added a tourist court to its holdings. It offered 30 modern cabins with 30 bathrooms. (Author's collection/E. C. Kropp Company postcard.)

And if Teibel's had no vacancies for the night, there was Barman's Tourist Court in Dyer. The row of white cabins can be seen above the open field a few blocks to the right of the intersection of Adeway and the LH. Barman's included a service station on the property. There was a restaurant about two blocks west that offered sandwiches and plate lunches. (Courtesy of Dyer Historical Society.)

If one preferred a hotel, the State Line Hotel on the corner of the LH and Adeway had 25 beds and offered both the American and European plans in 1916. All tourist accommodations by this time were subject to sanitation regulations. Adeway had become Hart Street by the time of this photograph, and in the 1930s, the feeder route and U.S. 41 were shifted to the intersection at Teibel's corners. (Courtesy of Dyer Historical Society.)

Smaller towns like Dyer and Geneva had supported hotels long before the automobile era. Bigger towns like Joliet and Aurora had bigger establishments and more of them. The Woodruff Hotel, opposite the Joliet Union Station, advertised itself as a European-style hotel with a café and 50 rooms with baths. It was endorsed by the LHA and the Chicago Motor Club. A room without a bath cost $1.50 a night. (Courtesy of Lake County Discovery Museum/Curt Teich postcard.)

As important as a night's lodging was, finding a filling station could be even more urgent. Gas stations, the first structures built in response to motoring, sold gas, oil, parts, and accessories. They would store customers' cars overnight or for the winter. Some of them doubled as the local tourism office, often staying open 24 hours a day. Smiling Service, in its neat prairie-style building, served travelers in Schererville. (Courtesy of Schererville Historical Society.)

It would seem that John Thiel of Schererville easily made the transition from horse and buggy to horse-powered engine. The smithy had been founded by his father in 1876. In 1903, John took over. In 1910, he poses with a wagon wheel he had made. By 1930, his building had been moved a few feet back to accommodate the widening and paving of the LH. In August 1923, a Massachusetts family was stranded in Schererville for two days while both cars were repaired. They set up their tents in the school yard, and while the men worked on the cars, the women did laundry and wrote letters. In 1924, Schererville still had no hotel, but the LHA guidebook recommended a free campsite "in a grove of oaks on the south side of the Ideal Section, west of the farmhouse." (Courtesy of Schererville Historical Society.)

Dyer Auto Auction and Prieu Auto Repairs occupied a prominent spot on the LH, where they sold Shell gasoline. In 1915, Dyer dealers sold gasoline for 15¢ a gallon and charged 50¢ for a quart of oil. Indiana began collecting a motor fuel tax in 1923. By the late 1960s, this building had been converted into a grocery store. (Courtesy of Dyer Historical Society.)

South Chicago Heights was a bedroom community south of Chicago Heights. Most of its German, Italian, and Polish residents were employed by the mills and factories in Chicago Heights. Nick Terre, above, ran this gas station on the LH, which was also the Dixie Highway at that point, in the 1920s. With the opportunity for federal funds to construct roads, Indiana and Illinois had established state highway commissions by 1919. (Author's collection.)

A gas station had to look like a gas station in order to be noticed by the passing motorist even in the early years when the speed limit was often only 15 miles per hour through town. Pagoria's in Chicago Heights was designed with plenty of space to store accessories and to work on cars. The Chicago Heights Tire Hospital and the Superior Battery Station also provided help for the motorist in trouble. (Courtesy of Chicago Heights Public Library.)

An up-and-coming town like Aurora had to offer both train service and a livery for long-term automobile storage. Some filling stations sold automobiles as well as gas and other motoring supplies, as did this Cadillac/LaSalle dealership. Egermann's Motor Sales Company on Downer Place was the "official" LH garage in 1915, offering gas, oil, automotive supplies, and repair service 24 hours a day. (Courtesy of Ruth Frantz.)

In the early days of the LH, Aurora had 10 filling stations. No doubt there were many more by the late 1940s, causing Aurora Tire and Battery Service to employ a layaway plan as well as pretty girls in order to maintain a competitive edge. In the late 1930s, some Illinois gas stations also hosted first aid stations that were on call to help state police at accident scenes. (Courtesy of Ruth Frantz.)

The development years of the gas station took place during the City Beautiful movement. Stations like this Pure Oil in Geneva, now a garden center, were designed to look like residential architecture. So they often looked like houses, even though, as in this case, the building was located on a commercial stretch of the LH at Fifth Street. Aurora and North Aurora also had similar Pure Oil stations on the highway. (Author's collection.)

Standard Oil built four refineries in the Chicago area, including one at Joliet. Shown here is the office building on Cass Avenue/LH along with a filling station. Illinois had about 160 automobile manufacturers, and until the late 1920s, Indianapolis was one of the automobile capitals of the world. The first car to have a clutch and electric ignition was made in Kokomo, Indiana, by Elwood Haynes in 1894. The next year, the first American automobile race was staged between Chicago and Evanston. Although most of the builders were really assemblers of automobiles from purchased parts, for example, Orrin Fitch in Dyer, some were designing and manufacturing their own brands. Aurora had six makes, Joliet had three. These tiny firms eventually either went bankrupt or were forced to move. Dr. James Selkirk of Aurora produced one Kirksell in 1907 for $3,000 and then quietly went out of business. (Courtesy of Will County Historical Society.)

Increased automobile sales increased the demand for all-weather roads. After Congress authorized federal funds for road construction in 1916 and 1919, Illinois and Indiana matched those funds for their stretches of the interstate highways. So, along with the beautiful homes, businesses, and countryside, the LH tourist would have seen construction crews much as one does today. The day this picture was taken, while this crew finished working on the intersection of the LH and Western Avenue near Chicago Heights, Charles Lindbergh was landing in Paris after his historic solo flight across the Atlantic Ocean. About this time, the federal government designated the westbound LH in Geneva, along with its feeder route, Roosevelt Road, as Federal Aid Route 330. The southeastern leg of Route 330 was today's Torrence Avenue. The stretch of the LH from the Indiana border to Geneva was now called State Route 22. (Courtesy of Chicago Heights Public Library.)

Along with the conveniences needed by travelers, the LH around Chicago also offered many things to see and do. On 10 acres of what had once been the Ideal Campground rose Meyer's Castle. Joseph Meyer, a banker and owner of the Indiana Botanic Gardens, hired architect L. Cosby Bernard Sr. to build his Jacobean Revival limestone mansion in 1932. Today the building houses an Argentinian restaurant known as Meyer's Castle. (Courtesy of Dyer Historical Society.)

After the dunes in western Indiana, motorists found themselves running on gentle hills and curves through the marshy areas around Sauk Village in Cook County. Settled by German Catholics from Alsace-Lorraine in 1839, Sauk Village was still known as Strassburg when the LH came through. With the Calumet Expressway in 1956 came housing developments, yet the area remained fairly rural throughout the 20th century. (Courtesy of LHA collection/University of Michigan.)

If they had pushed through Dyer and on to Chicago Heights, weary travelers might have checked in at the Victoria Hotel or Thomas Hotel for the night and stored their cars for the night at a local garage. They might then have walked a few blocks west to the Dixie Buffet for a bite to eat and taken in a movie at the Lincoln-Dixie Theater (above). The Victoria Hotel had been built in 1892 according to plans drawn by Louis Sullivan. The Lincoln-Dixie Theater paid tribute to the two transcontinental routes that used the same alignment for two miles in Chicago Heights and South Chicago Heights. Opened in 1921, the Lincoln-Dixie could accommodate 2,500 spectators and hosted vaudeville, operatic performances, and first-run movies. The theater was located just north of the intersection of Illinois Street with the LH. It was demolished in 1972. (Courtesy of Chicago Heights Public Library.)

The LH was conceived in the heyday of the women's club movement, and the Illinois Federation of Women's Clubs had conservation committees that rallied support for the beautification of the highway. The Chicago Heights Women's Club belonged to the Third District, which included the Arché Club of Chicago. (The Joliet, Aurora, Batavia and Geneva clubs were in the 11th District.) The Arché Club donated and installed this fountain—known today as the Arché Fountain—on the northwest corner of the LH and the Dixie Highway in October 1916. William G. Edens accepted the monument to Abraham Lincoln in the name of the LH. The inscription reads, "'To the support of the constitution and laws let every American pledge his life, his property and his sacred Honor.' A. Lincoln." On the reverse is a relief bust of Lincoln similar to the one on the penny. (Courtesy of Chicago Heights Public Library.)

Olympia Fields Country Club Rustic Bridge to Tent Colony

Beyond the lilac bushes that lined the LH was the pleasant atmosphere of the Olympia Fields Country Club summer tent colony. On the highway itself, year-round resident Olive Hammer operated the Tea Cupboard, which sold homemade beverages, sandwiches, and sweets to travelers. During Chicago's Century of Progress fair, the Nussbaum family maintained six octagon-shaped cabins for LH travelers who would take the train to the fair. (Courtesy of Olympia Fields Country Club.)

New Lenox grew out of the 19th-century "Hickory Creek Settlement." During the back-to-the-land movement of the 1920s and 1930s, small farms, poultry yards, and kitchen gardens appeared on both sides of the highway there. Jessica Helson North, in *Arden Acres*, described the phenomenon as "income homes and chicken houses." The Schmuhl School, above, was built in 1920. New Lenox also had one hotel and one garage for tourists. (Author's collection.)

Oakwoods Cemetery on the east side of Joliet attracted tourists interested in cemetery art and picturesque vistas of the ravines, hills, and forests of Will County. A Native American mound excavated there in 1928 by the University of Chicago was found to be 1,000 years old. The cemetery was also the burial place of Joel Matteson, an early Joliet settler and entrepreneur, an Illinois governor, and the namesake of Matteson, Illinois. (Author's collection.)

Crossing the Des Plaines River, one of the first sights the traveler would have seen was the College of St. Francis, a Catholic women's school established in 1925 by the Sisters of St. Francis of Mary Immaculate. The convent, shown here, was built of Joliet limestone. The same stone, also called Athens marble, was used in the construction of the famed water tower on Chicago's Near North Side. (Author's collection/Artvue Post Card Company.)

Beyond Plainfield was Wheatland Township. Settled in the 1840s, the township was notable for never having a village. With very little woodland, it became the finest farming and grain-producing section of Will County. The closest thing to a village was the corner of Heggs Road (LH) and 119th Street where the Wheatland Presbyterian Church (above) was built. Across the street was the 1928 Church School of District 38. (Author's collection.)

Aurora, on the Fox River, was variously described as "an outpost of the metro industrial area," "a farm town with 140 factories," or the place "where factories make their last stand against a checkered prairie." Manufacturers there made everything from excavation equipment and elevators to pumps and parachutes. Yet, just beyond the city limits, farming was still the basic industry. (Author's collection.)

Bellevue Place, Batavia, Ill.

This building, two blocks west of the LH on Jefferson Street, was constructed in 1856 as the Batavia Institute. In 1867, it was purchased by Dr. R. J. Patterson, who converted it into Bellevue Asylum for people with mental and nervous disorders. In 1875, Bellevue was home to Mary Todd Lincoln for three months as she recovered from the trauma of her sons' deaths and her husband's assassination. (Courtesy of Batavia Historical Society.)

Coming out of the woods of Batavia, the traveler's eye would have been dazzled by the glass-block and glazed-brick exterior of the "streamline moderne" Campana building. Makers of beauty potions, the Campana Company opened this facility in 1937 on the west side of the LH between Batavia and Geneva. There the plant welcomed visitors six days a week to hourly tours of its operations. (Author's collection.)

By 1928, the goals of the LHA had been met. As the federal government, in the name of efficiency and clarity, systematized interstate highways around the nation, highway names were replaced by numbers. The LHA set out to memorialize its work by installing concrete markers every mile and at important intersections on the highway. Austin Bement, Gael Hoag, and Sidney Waldon of the LHA designed the markers. With blue embossed and painted arrows on the sides, the reinforced concrete posts showed travelers when to turn or go straight. The front of each marker carried the red, white, and blue LH logo and a bronze relief bust of Abraham Lincoln. Approximately 175 of these markers were placed between Schererville and Geneva. The placement of the markers did not memorialize the original route but instead guided motorists through on the straighter second-generation Route 30. (Author's collection.)

Four

A Different Kind of Interurban

The LHA was smart in choosing the route around Chicago that it did. First, it was as improved as any section elsewhere in the country, that is, hard-surfaced in the cities and graveled in the countryside. Second, it was a proven route, already served by electric interurban lines, which, for many miles, ran on the same alignment. The interurban was an electric-powered rail line designed primarily for short-distance passenger transport. By 1914, Indiana ranked second in the nation with 1,825 interurban miles; in 1927, forty-seven electric railway companies operated on 2,000 miles of track in Illinois. One could ride the interurban from Geneva to Chicago Heights. From Chicago Heights to Schererville, folks rode the dinky (a small passenger car attached to the back of a freight train). The LH crossed at least 11 steam rail lines in its loop around Chicago in 1913, but by the mid-1920s, motorcars and buses were the dominant means of passenger transportation. Once people could just hop in the car for a shopping trip to the biggest city in the area, small-town merchants lost business. After World War II, housing developments in Chicago Heights, Olympia Fields, and North Aurora sprawled as former GIs and their families bought cars and new houses. In one case an entire town, Park Forest, was created. And so, because almost every town on the LH was also a town with a railroad station that offered connections to Chicago, suburban commuters used the highway to get to and from home and the train station. On weekends, they used the highway to reach amusements and shopping facilities. Highway motels also did good business, serving as temporary homes for these families as well as for the business traveler. As the suburbs sprawled, they spawned shopping malls on the outskirts of Joliet, Aurora, and Chicago Heights that could only be reached by automobile. By 1960, the LH had evolved into a new kind of interurban—a concrete connector among suburbs and a link in the region's intermodal transportation system.

The Joliet and Southern, later the Joliet and Eastern (J&E), interurban reached Chicago Heights via New Lenox in 1909. Service ended in 1922 when the Illinois Central Railroad elevated its track bed and the J&E could not afford to remodel its overpass. As the J&E's sister line, the Aurora, Plainfield and Joliet Railroad, ceased operations in 1924 and the CA&E in 1957, the LH became the new interurban. (Author's collection.)

Buses replaced the J&E in 1922. This bus went to the east side of Chicago Heights. The Gold Star line connected downtown Joliet to Hammond, Indiana, via Dolton and Calumet City, Illinois, until the 1950s when Suburban Safeway Lines took over. Service on the LH was then cut back to a Frankfort–Chicago Heights route. (Courtesy of Paul Jaenicke.)

After World War II, the LH came into its own as a conduit for commuters to and from Chicago. Here at the Illinois Central station, the local bus waits on the Olympia Fields side. Joe Stella's IC Tavern (upper left) in Matteson opened in 1935 with a restaurant and a canopied Texaco gas station. Connelly's Coffee Shop was in the station (lower left). Connelly's received Olympia Fields' first commercial license in 1952. (Courtesy of Park Forest Historical Society.)

The EJ&E, Chicago's Outer Belt Line or the "J," was once owned by U.S. Steel. It paralleled the LH for much of its route around Chicago while hauling freight from Gary, Indiana, to Waukegan, Illinois. It is shown here at the Matteson station. Pres. Theodore Roosevelt's train used EJ&E tracks between Aurora and Joliet during his 1903 tour of the Midwest. The EJ&E discontinued passenger service in 1908. (Courtesy of William Molony/John F. Humiston photograph.)

Rock Island Depot, New Lenox, Ill.

The LHA guidebooks always pointed out which railroad crossings were protected and which were not. Here is the Rock Island Railroad depot at New Lenox, three blocks north of the LH. Westbound out of the station, the Rock Island paralleled the LH below grade just past Pilcher Park. There it crossed both Hickory Creek and the highway as it made its way southwest through Joliet and on to the Pacific Coast. (Courtesy of William Molony/Rock Island Railroad.)

UNION DEPOT FROM STREET LEVEL, JOLIET, ILL.—41

The Chicago, Rock Island and Pacific Railroad shared the Joliet Union Depot with the Chicago and Alton and the Atchison, Topeka and Santa Fe Railroads. Joliet had pioneered the elimination of at-grade railroad crossings between 1904 and 1914. Passenger service was consolidated in 1912 at the depot, located at Scott and Jefferson Streets. The Woodruff Hotel, an LH control point, was across the street, three blocks south of the highway. (Courtesy of Will County Historical Society/E. C. Kropp Company postcard.)

As indicated by this photograph, once the highway had been paved beyond the city limits of Chicago Heights, land along the highway became more desirable for housing. Most residential, and later commercial, development moved west on the highway along the bus route. From the 1960s through the end of the century, intensive commercial development around the Western Avenue–LH intersection created the "miracle mile" phenomenon. (Courtesy of Chicago Heights Public Library.)

Typical of the bungalow era of the 1920s is this house on the highway on the west side of Chicago Heights. It is located a few blocks west of the 1916 LH bridge over Thorn Creek and south of the Chicago Heights Country Club. Some of the earliest houses, including that of one of the McEldowney families, were also located along this stretch of the highway. (Author's collection.)

West of Chicago Heights in 1915, while most dwellings on the highway were farmhouses, members of the Olympia Fields Country Club were summering behind the lilacs at the club's tent colony. In 1919, sales of permanent home sites began on Kedzie Avenue. When the highway was paved and the Illinois Central became a commuter train—38 minutes to Chicago—development nearer the highway, east and west of the train station, occurred. (Courtesy of Olympia Fields Country Club.)

Olympia Fields was developed by Charles Beach as a getaway for wealthy Chicagoans. Their houses were built adjacent to the 674-acre country club comprising four 18-hole golf courses, a polo field, tennis courts, a trap-shooting range, and facilities for winter sports. In 1967, plans for the Maynegaite subdivision, its entrance seen here with the LH beyond, took shape on land that had once been the Second Course. (Author's collection.)

The Park Forest neighborhood of Lincolnwoods, across the street from Maynegaite, aptly illustrates a result of the national post–World War II housing boom. In creating Park Forest, American Community Builders opened the first planned residential community built with private financing in the nation. The first residents moved there in 1948, and in 1956, William Whyte used Park Forest as the location for his best-selling novel *The Organization Man*. Park Forest, Olympia Fields, and the LH made the local news when the blizzard of 1967 hit. By dusk on January 27, side streets were impassable and traffic was at a standstill on all the expressways and all the secondary roads—including the LH, shown here westbound—leading to every community near Chicago. The total accumulation of 23 inches set a record. Cars and trucks were strewn across lanes and hemmed in with snowdrifts. (Courtesy of Park Forest Historical Society.)

A mile west of Park Forest, another developer, Joseph O'Connor, created a smaller but charming neighborhood of tidy brick Cape Cods and winding streets on the north side of Matteson. The reasonably priced houses were also attractive to GI families. This view along Maple Street shows the LH in the background. (Author's collection.)

A preeminent architectural example of Joliet limestone is the Tudor-Gothic Joliet Township High School designed by Frank S. Allen and built in 1899. Its 2,100-seat auditorium was designed by the Daniel H. Burnham Company. The main floor featured murals by William Henderson. Tourists who stopped long enough to inspect the exterior walls might have spotted fossils embedded in the stones. (Author's collection /V. O. Hammond Publishing Company postcard.)

This is consul U. S. G. Blakely's house on the northwest corner of Division (LH) and Ottawa Streets in Plainfield. Note the addition of a brick porch to the frame Italianate. Plainfield's housing stock goes back to the 1830s when it was a bigger town than Joliet. Greek Revivals mixed with bungalows on the LH. Somewhat beyond the town's border was the childhood home of Thomas Alva Edison's wife, Mary. (Author's collection.)

The Plymouth Congregational Church in downtown Plainfield is an example of the frame, Greek Revival–style buildings scattered throughout the town. It was built in 1851 by members of the Congregational Church who had organized themselves in Plainfield in the 1830s. All but one of the commercial buildings on this stretch of the highway were there in 1913. (Author's collection.)

Its sign gives lie to the age of the Skyline Trailer Park on Hill Avenue (LH) in Aurora. All sorts of housing types appeared on the LH. Farther north on Hill Avenue and Benton Street, neighborhoods of frame bungalows and American foursquares mixed with brick mansions closer to the Fox River and the downtown islands, which are notable for their stylish commercial and public buildings. Aurora also has 136 authenticated Sears homes. (Author's collection.)

The LH bypassed North Aurora's downtown area. But there has always been significant commercial development on the highway too, although the north end is largely residential. Subdivisions on either side of the highway are notable for a variety of architecture from the prairie style to old farmhouses and from Tudor Revival to ranch. Much of this development took place in the 1960s. (Author's collection.)

Batavia's main commercial area is east of the highway on islands in the Fox River. But this stretch of the LH had its commercial development too, along with several imposing churches and private mansions, like Lockwood Hall and the Snow House at the south end of town. Broad lawns and massive shade trees framed idyllic views of houses all along the highway. (Author's collection.)

Geneva was the county seat for Kane County. As such, this impressive courthouse was constructed on the highway for government use. Most of the highway in Geneva was given over to commercial properties, but within a block in either direction of it, tall trees sheltered residential neighborhoods of 19th- and early-20th-century houses. One of the 1928 concrete LH markers was placed in front of the courthouse. (Author's collection /Es-N-Len Photos.)

Shopping and other commercial development originated on the LH in bigger towns like Chicago Heights and Joliet. In the late 1940s when this photograph was made, residents of Matteson and Sauk Village came to Chicago Heights to buy dressy clothes, have lunch or dinner with friends, catch a movie, and take care of banking. But as the function of the highway changed, so did the city centers. (Courtesy of Chicago Heights Public Library.)

By 1960, the LH downtowns had moved to intersections outside the cities. Here the LH (top to bottom) meets Crawford Avenue and Governors Highway in Matteson and Olympia Fields. At one time, the gas station on the lower right-hand corner had been "out in the country." Now there were three other stations plus an E. J. Korvette shopping mall on the lower left corner. (Courtesy of Park Forest Historical Society.)

The same phenomenon occurred between Joliet and Plainfield and in Aurora. The Louis Joliet Mall opened in 1978, while the area of downtown Joliet around the LH went through an economic downturn. Similarly the Northgate Shopping Center stole the thunder from downtown Aurora in the 1950s. Both of these malls, as well as much of the retail commerce of Chicago Heights, however, had only moved somewhere else on the highway. The LH remained an important traffic artery. (Technically speaking, the location of the Northgate Shopping Center was Route 31.) Neon and the symbols of the space age were needed to lure motorists into the mall as speed limits increased. The sign has been designated as a local landmark. Both of these malls were bypassed to varying degrees by the Fox Valley Mall east of Aurora. (Author's collection.)

After the original route of the LH had been bypassed by Route 30, south of Aurora, Batavia's commercial strip on the highway catered mainly to local customers. Buildings from the 19th century, gas stations, franchises, and late-20th-century architecture accommodated small businesses and their patrons in the 1960s. (Courtesy of Batavia Historical Society.)

Ever since the CA&E veered onto Third Street, this Geneva neighborhood has been known for its upscale shopping. The Little Traveler (above) opened in the early 1920s when Kate Rafferty sold imported fancies from the top of her grand piano. Her home was later remodeled into the now-famous store that anchors the shopping district on Third Street, also known as the LH. (Author's collection.)

After World War II, the highway changed from catering to tourists to serving the local trade. Curb service appeared everywhere in the 1950s, although White Castle and A&W had been around since the 1920s. The 1954 Chevy ragtop, shown here, is parked at Martin's in Schererville, about the same time a Dog-N-Suds was opened on the LH in Matteson. (Courtesy of Schererville Historical Society.)

There were also one-of-a-kind places like Rudy's on Hill Avenue (the LH) in Aurora across the street from Phillips Park and next door to the Skyline Trailer Park. Rudy's evolved between 1924 and 1987 from Ray's Barbecue. Ray's supplied sandwiches, chips, and pop to the tourists who camped nearby in the 1920s and 1930s. The poolroom made Rudy's attractive to local residents as well. (Courtesy of Ruth Frantz.)

On the Phillips Park side of the highway was the drive-in known for many years as Swoney's. The architecture is so evocative of 1950s drive-ins that one can easily imagine "tray girls" delivering burgers, fries, and soft drinks to cars under the canopy, with a rock-and-roll beat in the background. Through a change in ownership, Swoney's became Doggie Diner, and the swoopy canopy now shelters tables and benches for self-serve customers. (Author's collection.)

The Abe Lincoln Motel in Frankfort is representative of mid-20th-century LH motels. The Lincoln Motel in Schererville, the Matteson Motel, and the Lake View Motel in Plainfield also provided temporary shelter for LH tourists, businessmen, and families waiting for their new houses to be finished. Some are still in operation at this writing. (Courtesy of Schererville Historical Society.)

Sauzer's Kiddieland was owned and operated by the Sauzer family of Schererville on property west of the intersection of the LH with U.S. 41. Kiddieland was a popular amusement for local children and their parents. Note the trees in the background. They were on the other side of the LH/Route 30 before it became a miracle mile and the land was developed with motels, restaurants, and office space. (Courtesy of Schererville Historical Society.)

The Ideal Section started about a half mile west of Kiddieland and ended in Dyer. In 1969, the Timothy Ball chapter of the Daughters of the American Revolution removed the original memorial for the highway and replaced it with this three-paneled version. The outer panels were from the original Ideal Section memorial placed by the LHA in 1923. The center panel commemorates the history of the Sauk Trail. (Courtesy of Dyer Historical Society.)

The third version of the Olympia Fields Country Club clubhouse (above) was finished in 1925. Since then the English Tudor building has hosted not only members but an array of professional golfers from Bobby Jones to Tiger Woods. Club membership dwindled during World War II, so 341.33 acres closest to the LH were sold in 1944, making way for the development of the village of Olympia Fields east of the Illinois Central tracks. (Courtesy of Olympia Fields Country Club.)

For a while, Pilcher Park continued to serve campers, but as their numbers dwindled in the 1930s, the park and its shelter on Hickory Creek became known as a local picnic ground, where visitors whiled away their afternoons wandering through the gardens and arboretum. The statue above, made by Leonard Crunelle, memorializes Robert Pilcher, who donated the acreage to the City of Joliet in 1922. (Author's collection.)

If the tourists knew where to look beyond the trees and the post–World War II building development, they could join locals for picnics or walks along the banks of the Fox River in Batavia. A visit to the Fabyan estate, site of the former Riverbank Laboratories, was also a pleasant afternoon activity. The Riverbank factory was established in 1919 by Col. George Fabyan for the manufacture of acoustic devices such as tuning forks and sound meters. Frank Lloyd Wright remodeled the farmhouse that was original to the site. The Fabyan estate with its Japanese garden, shown here below, and windmill (above in distance) became part of the Kane County Forest Preserve District after the death of Nelle Fabyan in 1938. Soon after the acquisition, the site became one of the most popular tourist attractions in the county. (Author's collection.)

In the late 1980s, the elevated Illinois Central station at 211th Street/LH was demolished and replaced with the "intermodal transportation hub" shown above. Joe Stella's IC Tavern and Connelly's Coffee Shop were replaced by a bus turnaround and brand-new ticket office and waiting area. No longer the Illinois Central, it was now called the Metropolitan Suburban Commuter System, or Metra. The LH was widened from four to six lanes in 1984. This paved the way, so to speak, for the development of a miracle mile on the LH in south Cook County. The commercial district of Chicago Heights had already moved west to the city's boundary. There Park Forest and Olympia Fields contributed more restaurants, automobile dealerships, and office buildings. From this Metra station west to Cicero Avenue and on to the Interstate 57 interchange, Matteson and Olympia Fields encouraged development of the corridor with gas stations, a regional shopping center, and strip malls. (Author's collection.)

Five

How the Bypass Was Bypassed

Between 1913 and 1964, the LH lost its preeminence as a transcontinental highway. The first bypasses in the Chicago area came in the late 1920s when the original route was superseded by the second-generation LH. The federal government and state highway commissions straightened and redesignated the road between Dyer and Chicago Heights. The same thing happened between Plainfield and Aurora where the road changed from the stair-step through the countryside to a sleek swath straight from Plainfield to Aurora. And the LH, along with all the other named routes in the country, became a number: Route 30 on the southern and southwestern legs and Route 31 through the Fox Valley. In 1956, Pres. Dwight D. Eisenhower signed the Interstate Highway System into law, and by 1964, Interstate 80 had bypassed the LH around Chicago.

This photograph shows how the old LH was bypassed in Schererville. The original route begins in the lower right corner, crosses the four-lane Route 30, then curves back toward the railroad tracks (see overpass on Route 30) where it dead ends. Previously the LH had continued due west behind the office buildings (upper right) and then curved to the right to meet what is now the Route 30 alignment. In 1928, the much straighter alignment of Route 30 was put through beginning at Fort Wayne, Indiana. From there, this new road bypassed all the towns of the original route except Schererville and Dyer. In 1922, when the Ideal Section was being designed, the LHA had planned to run it from what is now U.S. 41 (see road to right of the office buildings) west through Dyer, but they could not secure a right-of-way through the farm of Jacob Miller. So the Ideal Section ended prematurely at the point mentioned above where the old LH curved to the right and met Route 30. (Courtesy of Schererville Historical Society.)

Beyond the Ideal Section, the LH proceeded directly toward the state line (upper left) via Dyer. There it originally made a left turn and continued west to Strassburg. But as early as 1919, that route was being bypassed by making a right at the same intersection and then crossing the EJ&E and Michigan Central Railroad tracks to the next intersection where a left was made onto Fourteenth Street, later Route 30. (Courtesy of Dyer Historical Society.)

Standing about a quarter mile west of Dyer near the Sauk Trail intersection are, from left to right, Louise Jaenicke, Ernest Houck, and Lillian Houck in the early 1930s. About this time, the LH around Chicago was designated as the 22 Loop. Also known as State Bond Issue (SBI) Route 22, it ran from the border in Lynwood through Aurora where it picked up today's Route 31 through the Fox Valley. (Courtesy of Paul Jaenicke.)

"Last Stop Illinois Prices"—some things do not change. This is Long's Motel and restaurant on Route 30 at the state line where motorists were cautioned about crossing to Indiana without filling up first. Long's also claimed to specialize in fine food and "modern, restful" overnight accommodations. By the 1950s, the management had expanded its services to include banquet rooms and a "swimming pool for splash parties." (Courtesy of Chicago Heights Public Library/E. C. Kropp Company postcard.)

Fourteenth Street between Chicago Heights and the Indiana border was designated State Route 22 in 1923 and consequently paved about that time. This concrete bridge over Deer Creek in Ford Heights, four miles west of Dyer, was part of the project. Plans also called for the north–south range road, today's Torrence Avenue, to be paved as far south as the Will County line via State Route 22 and the LH. (Courtesy of LHA collection/University of Michigan.)

THE HI HAT CLUB

ROSE HELFER, Manager

ANNOUNCING GALA NEW YEAR'S EVE CARNIVAL PARTY
Featuring Twin Fan Dancing Blondes, Daring Sensational Wanda, and Others
SOUVENIRS AND FAVORS FOR EVERYONE

ONE MILE WEST OF DYER ROUTE NO. 30 LINCOLN HIGHWAY

TAXI Phone 620 **Bright Lights Map and Directory** TAXI Phone 62

PHONE: LANSING 19 FISH FRY FRID

AUTO INN

CHAS. ZITEK, Prop.

OD BEER FOR 5c Original Colored Jug Band Saturday and Sunday Nigh
CHILE — SANDWICHES
OAK GLEN, ILLINOIS CORNER RIDGE ROAD and TORRENCE AVE.

The loneliness of the corn and onion fields on either side of the "new" LH became a magnet for roadhouses through the end of Prohibition and into the 1940s. This map is an excerpt from a little advertising tabloid called *Bright Lights*. It not only featured clubs and restaurants from Dyer to Chicago Heights on Route 30 but also offered readers risqué anecdotes and jokes. The map also shows Torrence Avenue, which by now had usurped the Dixie Highway (Chicago Road on the map) as the first Illinois feeder route into Chicago. Some years later the Route 30 Motor Lodge Motel was built west of this intersection. In 1928, the LHA placed one concrete memorial marker within 50 feet of Torrence Avenue in both directions. (Author's collection.)

The landscape on Route 30 became industrial in Chicago Heights. Columbia Tool Steel Company, at State Street, would have been spotted by tourists because there was a concrete LH marker on the corner in front of the plant. Visitors in the 1930s liked to tour factories, and Columbia Tool would accommodate them by appointment while the nearby Illinois Glass Factory welcomed all comers, any time. (Courtesy of Chicago Heights Public Library.)

Mixed in with taverns, factories, and apartments were neighborhood theaters like the Liberty. *Buck Privates*, a 1941 release, featured Abbott and Costello in their first starring role and the Andrew Sisters debuting "Boogie Woogie Bugle Boy." A few blocks west, Route 30 met up with the old LH. In the 1930s, the road to Joliet was described as "uneventful . . . through half-completed subdivisions, big truck gardens and wooded pasture land." (Courtesy of Chicago Heights Public Library/Dick Zaranti.)

After Plainfield, the original LH turned north about a half mile west of the DuPage River. It then stair-stepped northwest across Will County. In 1924, Route 30 turned north at the same corner but continued north/northwest to where it met the old LH (the dark automobile) at Harvey Road just south of the Lincoln Memorial Park cemetery (the dark tree on the right). In Aurora, Ohio Street was the original route; in 1928, the route moved one block east to Hill Avenue. From either street, the motorist then turned west on Benton Street. Before the Benton Street bridge was built in the mid-1920s, the LH turned north for one block on LaSalle Street and then went west on Fox Street in order to cross the river and turn north. After 1937, Route 30 continued west out of Aurora on Galena Boulevard and it later avoided downtown Aurora completely with a cutoff from Oswego Road. (Courtesy of Ruth Frantz.)

Once the LH bypassed Aurora, transcontinental travelers also missed North Aurora, Batavia, and Geneva. In the late 1930s, interest in the LH revived and local boosters mounted this billboard, which emphasized the original route of the LH, now Route 31, and urged travelers to enjoy the scenic Fox Valley instead of the boring old farmland on Route 30 to Dixon where it would meet up with the original LH/Route 38 anyway. (Courtesy of Ruth Frantz.)

Although much of the LH is lined with houses, much of it also looks like this. This view was taken at Teibel's restaurant in Schererville, looking north on U.S. 41, which had superseded Adeway or Hart Street in Dyer as the Indiana feeder route to Chicago. The same sort of commercial development and traffic load is present on Route 30 east and Route 30 west. Areas like this have become known as miracle miles. (Courtesy of Schererville Historical Society.)

West of the Torrence Avenue junction with Route 30/LH is that of Illinois 394, shown here southbound at the LH overpass in Chicago Heights. Since its opening in the 1960s, it has been designated as State Route 1, State Route 83, and Toll U.S. 30. Only 10 miles long, it runs between Interstate 80 and the current State Route 1, in effect acting as a feeder route for Interstate 80. (Author's collection.)

St. James Hospital had replaced the Arché Fountain as the landmark at the intersection of the Dixie Highway and the LH in Chicago Heights by the 1950s. The Dixie Highway itself had been replaced as a feeder route to Chicago from the south by the more direct route of Torrence Avenue/Route 330, which connected in Chicago's Loop to Roosevelt Road/Route 330. (Courtesy of Chicago Heights Public Library.)

Interstate 57, seen in the distance from eastbound LH, opened in 1968. By 1973, the passing motorist might have shopped at Lincoln Mall a few blocks east and by 2003 might have bought the latest in SUVs at the Auto Mall (right). The Auto Mall, in Matteson, encouraged the westward movement of commercial development on the highway by attracting dealerships formerly doing business in Chicago Heights and Olympia Fields. (Author's collection.)

By 1964, the Route 30/Interstate 80 interchange at New Lenox was open. As the new transcontinental highway between New York and San Francisco, Interstate 80 was the bypass that everyone thought would kill the LH. But as drive-ins and department stores continued to flourish, local merchants barely noticed the 20 percent decrease in traffic. Saturday night was still the big night for shopping in commercial districts from Schererville to Geneva. (Author's collection.)

Seen here passing over the LH on the west side of Joliet is Interstate 55, which opened in 1964. It is 963.5 miles long, and it runs from La Place, Louisiana, to McCormick Place in Chicago via St. Louis. Originally called the Southwest Expressway, it was renamed the Adlai E. Stevenson Expressway in honor of a former Illinois governor. The Illinois stretch of Interstate 57 is the bypass for the old Route 66. (Author's collection.)

This perspective of westbound Interstate 88 between Aurora and North Aurora (left and right, respectively) shows how Route 31/LH passes overhead. Interstate 88 superseded Route 30 in 1973 but meets it and Route 38 (old LH) near Dixon. When the Illinois tollway system opened in 1958, engineers estimated 70 percent of its traffic was long distance; by the end of the 20th century it was 70 percent local. (Author's collection.)

105

Once the interstates were built, the LH underwent renovations. As one westbound lane in Dyer, above, was finished, another was prepped by grading and placing rebar. This time the department of transportation did not have to build a railroad to transport concrete materials to the paver. Trucks brought them to the site already mixed. The new concrete lays roughly where the narrow-gauge rail tracks were located in 1922. (Courtesy of Schererville Historical Society.)

The paver cometh. Traffic was shunted to the eastbound lanes in Dyer in September 1994 as the crew placed concrete for the westbound lanes. Although the paving machinery had not changed much in 70 years, the reinforcing steel had. Instead of mats of dowels set at right angles to each other, the bars were now placed and tied to chairs, which insured placement at the proper depth. (Courtesy of Schererville Historical Society.)

This is the eastbound Ideal Section in September 1994 before reconstruction. The photograph was taken near Great Lakes Drive, close to the proposed location of the Ideal Campsite and gas station in the trees to the right. In 1930, the Ideal Section was finally connected to Route 30 at its junction with U.S. 41, approximately one mile east of this photograph location. (Courtesy of Schererville Historical Society.)

This is the westbound Ideal Section as it looked in September 1994 before reconstruction began. The western edge of the 10-inch reinforced concrete was located roughly at the monolithic sign on the left side of the road. News stories in 1922 and 1923 claimed that the Ideal Section would never wear out and that a syndicate of Chicago businessmen was planning to build 500-room hotel somewhere in this area. (Courtesy of Schererville Historical Society.)

This is the Dyer curve, looking east, during the 1994 reconstruction, which included the widening of the LH west to the Illinois state line. In the distance is St. Joseph's Church from where Herman Teutemacher took the photograph of this stretch of the highway in 1903. The LH bridge over Plum Creek is to the left, just out of the photograph. Behind the photographer was the intersection of the LH with Adeway. August W. Stommel's bank, the Cheap Store, and his father's hotel had all been demolished to make way for the reconfiguration of that intersection. Farmhouses and 19th-century stores were replaced with three-story office buildings, franchised gas stations and restaurants, and a locally owned chain grocery store. The Dyer Village Hall, which houses the historical society, was built near a small park on the banks of Plum Creek on the south side of the LH. (Courtesy of Schererville Historical Society.)

Six

THE HIGHWAY AS DESTINATION

A funny thing happened to the highway that once carried tourists to their vacation destinations—it became a tourist attraction itself. By the end of the 20th century, nearly 100 years from its inception, the LH became the object of some 3,000 miles of preservation activity. In 1992, the LHA was reborn in Iowa. Within a year, all of the 13 LH states had organized chapters and many of them had also created tourism organizations. In Illinois, the crowning touch was the designation of the highway throughout the state as a national scenic byway in 2000. In both Indiana and Illinois, preservation and promotion have included painting the LH logo on utility poles; rededicating landmarks; erecting statues, historical markers, and interpretive signage; sponsoring vintage car rallies; maintaining Web sites; and researching the history of the road—even if it meant pestering road crews in order to get photographs of the highway's original pavement before it was torn out forever. Today's LH tourists are just as likely to be from Japan or Luxembourg as they are from Dubuque or Cheyenne. School kids everywhere still get a thrill out of knowing that their school bus runs on a road that could take them to San Francisco or downtown New York City if they just kept on driving.

After the Indiana chapter of the LHA was organized in 1993, members presented the highway's history through meetings, road rallies, and other activities. Here chapter president Glen Eberly demonstrates how homemade stencils were used to repaint the LH logo on poles along the original route in Schererville and Dyer. This pole was on the corner of the old LH and U.S. 41 in Schererville. (Courtesy of Schererville Historical Society.)

In the autumn of 1994, Dennis and Dan Kwiatkowski replaced three stones near the top of the curve on the left side of the Ideal Section monument. This memorial had been placed in front of the bench in 1969 by the Timothy Ball chapter of the Daughters of the American Revolution as a tribute to the LH and the Sauk Trail. In doing this, they removed the Ideal Section monument that had been placed there in 1923 by the LHA. However, they kept the original plates and reinstalled them on the new monument. (Courtesy of Schererville Historical Society.)

In 1994, Bill Gettler, part of the road crew in 1922, showed Art Schweitzer where to look for the endpoints of the Ideal Section. He showed him other sites like the railroad siding where construction materials were delivered and the route of the small-gauge railroad that transported them to the paving machine. In this photograph he is standing at the former location of the Ideal Section billboard (see the photograph in his hand). (Courtesy of Schererville Historical Society.)

Art Schweitzer spearheaded most of the LH-Indiana research and public events in the mid-1990s. He is shown here painting the embossed lettering of the new Ideal Section bridge in 1996. Schweitzer made the stamps for the letters and spent countless hours from 1996 through 1998 with Indiana Department of Transportation engineers and road crews documenting the right-of-way and salvaging what he could of the Ideal Section before it was demolished. (Courtesy of Schererville Historical Society.)

The same sort of activities occurred on the Illinois side. Nanette Wargo of Sauk Village got into logo painting too. Others in Sauk Village worked with Art Schweitzer of Schererville to capture the history of the LH with particular focus on the Kalvelage bridge, which played an important role in the early highway. The Nancy L. McConathy Public Library, under Wargo's direction, has made the materials accessible to the public. (Courtesy of Nancy L. McConathy Public Library.)

The Illinois LHA chapter was organized in 1993 too. From left to right are Sue Jacobson, Ruth Frantz, Clare Frantz, and Carl Jacobsen, all from the Aurora area, on an early outing to see what the highway looked like at the Indiana border. Since the early days of the highway, Lynwood, Illinois, had annexed property up to the state line. Long's Motel was formerly within a block or two of this location. (Courtesy of Ruth Frantz.)

In October 1995, the Indiana chapter orchestrated Schererville, Dyer, and Sauk Village members in a rededication of the highway, including the Kalvelage bridge in Sauk Village. A parade of vintage cars led to the starting point at Sterk's Plaza in Sauk Village. Afterward the group went back to Indiana to unveil the Indiana state historical markers at either end of the Ideal Section and to see the restored Ideal Section monument. (Courtesy of Nancy L. McConathy Public Library.)

Sterk's Plaza, on the west side of the Lincoln-Lansing Ditch, was a place to leave the cars while a marker was installed commemorating the Kalvelage bridge and the original route of the LH, which crossed it between 1913 and 1927. Nothing remains of the wooden bridge that was replaced by a cement two-lane bridge. The latter was removed during roadwork in the 1980s. (Courtesy of Nancy L. McConathy Public Library.)

Among the attendees at the dedications were, from left to right, Lance "Abraham Lincoln" Mack; Irene Kalvelage; Mark Collins, mayor of Sauk Village; and Edward Kalvelage. The Kalvelages were a brother and sister who remembered the highway when the wooden bridge was there and the road was still graveled. From the Kalvelage bridge, the car caravan returned to Dyer. (Courtesy of Nancy L. McConathy Public Library.)

In Dyer, the new LH bridge over Plum Creek was opened with a ceremony at the nearby Dyer Village Hall. After music and speeches, the group moved on to unveil the Indiana state historical markers installed at the west and east ends of the Ideal Section. The event also celebrated the completion of the widening of Route 30 from Hart Street to the Illinois state line. (Courtesy of Schererville Historical Society.)

The final event of the day was the dedication of the Indiana state historical markers denoting both ends of the Ideal Section. Esther Oyster Queneau, then vice president of the LHA, was on hand for this along with other LHA members from Ohio, Iowa, Indiana, and Illinois. She is standing near the eastern end marker at the corner of Janice Lane. (Courtesy of Dyer Historical Society.)

It was a cold day in November 1996 when students from the Watson School in Schererville dedicated the new Ideal Section bridge. The children cut the red ribbons, which freed the white ribbon that was attached to a bottle of wine that, upon breaking, christened the new bridge. Several LHA members from Illinois and Ohio also attended the dedication. (Courtesy of Schererville Historical Society.)

April 18, 1997, was the day they ripped up the west end of the original Ideal Section pavement in Dyer. A crawler-mounted, hydraulically operated hoe did the deed as Art Schweitzer and others watched. In the debris they found lead-covered lengths of the original lighting cable and samples of square steel dowels unlike the round reinforcing bars that are used today. The east end was demolished in the summer of 1998. (Courtesy of Schererville Historical Society.)

In 1998, when the underpinnings of the east end of the Ideal Section near the old LH were unearthed, there was the 10-inch concrete with rebar next to the 8-inch nonreinforced cement of 1927, just as Bill Gettler had said there would be. This is where Jacob Miller's property line had halted construction of a two-mile Ideal Section. Indiana acquired that right-of-way in 1926. Later both sections were surfaced with asphalt. (Courtesy of Schererville Historical Society.)

As the reconstruction and repaving of the Ideal Section were completed in 1997 and 1998, station numbers were embossed in the concrete to mark both ends of the Ideal Section. The east end is denoted by 124+55.6; 44+20 10-2-97 denotes the west end and the date on which the number was pressed into the wet cement. The distance between the two is one and a half miles. At the west end, 10-inch-thick concrete was found in the section where the four lanes tapered to two. The tapered section measured about two-tenths of a mile. Art Schweitzer, on hand to record all the reconstruction of the Ideal Section, discovered pieces of underground cable from the original Ideal Section lighting system in this area. (Courtesy of Schererville Historical Society.)

The eastbound Ideal Section is shown in the photograph above as it looked after reconstruction in the 1990s. The Ideal Campsite would have been built on the dunes in the trees to the right. The Ostermann bench and the Ideal Section memorial were still on the road in front of the dune. The photograph below shows the Ideal Section westbound. Both photographs were taken near the Sand Ridge Plaza at Great Lakes Drive in Dyer. After reconstruction, commercial development increased in the "outlots" close to the highway, while within a block or two north and south of the highway acres of new houses popped up, seemingly overnight. The Ideal Section road crews of 1922 would probably have recognized the plant life near the curb though. (Author's collection.)

In June 1999, Dr. Alan Hathaway of Davenport, Iowa, drove out of New York City in the 10 millionth Model T ever made. He celebrated the diamond anniversary of his 1924 Ford by taking it across the country. On June 10, he displayed the car at the Ford stamping plant in Chicago Heights, which is located on Route 30. Hathaway arrived in San Francisco on June 19. (Courtesy of Schererville Historical Society.)

That same month, the Illinois chapter hosted the national LHA conference for the first time. Three days of the event were devoted to traveling the highway east and west of Rochelle, Illinois, the conference site. This photograph shows LHA members taking a walk through Mooseheart during part one of the "eastern tour." Part two covered the miracle mile portion of the highway around Matteson and Chicago Heights. (Courtesy of Schererville Historical Society.)

Denoting the spot where the Burgel Tavern and Inn once stood at Brown's Corners in South Chicago Heights, this plaque and garden also mark the intersection of the Sauk and Vincennes Trails, also known as the Lincoln and Dixie Highways, once a crossroads of national significance. Today travelers are welcomed by a Walgreen's drugstore where once they could have had a hot meal and a bed for the night. (Author's collection.)

Complementing the rehabilitated Arché Fountain on the southwest corner of the Chicago Heights intersection of the Dixie and Lincoln Highways is a bronze monument called A. Lincoln: On the Road to Greatness on the northeast corner. It commemorates Abraham Lincoln's life with a relief of his childhood log cabin and the White House as it looked in 1861. Lincoln is shown smiling as two girls offer him baskets of violets, the Illinois state flower. (Author's collection.)

Another piece in the LH gallery of midwestern art and architecture is this life-size sculpture of an LH construction worker at the corner of Theodore Street and the LH in Joliet. Dedicated on May 14, 2005, it is called *Building the Lincoln Highway* and represents a construction worker around 1915. The cold-cast bronze sculpture is mounted on a colorful mosaic column of ceramic tessera. The lead artist was Kathleen Farrell, assisted by Dante DiBartolo, Roberta Faulhaber, Kelly Gallaher, Emil Sauer, and Sarah Furst. The mosaic artist was David Yanchick. The project was sponsored by the City of Joliet and the Friends of Community Public Art along with the Three Rivers Construction Alliance and the National Endowment for the Arts. Its purpose was to honor the LH as well as the men and women who maintain the roads. (Author's collection.)

After enthusiasm for pole painting wore off, the LHA upgraded to metal signs and then to concrete posts in 1928. Lyn Protteau, who reprinted several LHA publications in the 1990s, stands next to the reinstalled marker on Smith Street just off Benton Street in Aurora. Many of the concrete posts have been damaged or destroyed, but occasionally they have been rescued and placed in a protected spot somewhere near the original route. (Courtesy of Ruth Frantz.)

In Plainfield, Lockport Street is also called Lincolnway. The LH banners remind travelers and residents alike that this street still connects Plainfield to the world. If that pickup pulled out and stayed with the road, next thing the driver knew, he or she would be in Lincoln Park at the edge of the Pacific Ocean in San Francisco—or in midtown Manhattan, New York City. (Author's collection.)

The Illinois Lincoln Highway Coalition (ILHC) was organized in the fall of 1997 by bed-and-breakfast owners Barb and Mike Winandy of Morrison, Illinois. Historians, businesspeople, economic development officers, tourism professionals, and Illinois Department of Transportation (IDOT) and LHA members came together to seek an Illinois Tourism Bureau grant. Although unsuccessful in becoming a tourism bureau "demonstration project," they did get IDOT to produce enough "historic route" signs to mark the original route across the state. (Courtesy of ILHC.)

However, the Illinois General Assembly did not approve the enabling legislation, and the 300 signs remained in a department of transportation warehouse. Only after the ILHC obtained national scenic byway status for the LH in Illinois in 2000 were they installed. The highway became a Heritage Tourism Demonstration Project in 2001. This sign is located at the intersection of Routes 30 and 7 (Joliet and Crest Hill). (Author's collection.)

Having decided to pursue scenic byway designation, the coalition asked Tom McAvoy of IDOT to write the proposal. As McAvoy has often said, before the ILHC, he only knew the LH as Route 30 in Will and Cook Counties and that IDOT owned it and maintained it. On June 15, 2000, the list of new byways was published and Illinois had made it! Now it was his turn. The following summer, he and the ILHC planned "Mad Mac's March." On the morning of September 1, 2001, Art Schweitzer from the Indiana LHA chapter set up an LH photograph display in the Lynwood Village Hall parking lot where the send-off party convened. Then the group moved on to the state line. McAvoy, second from right, wore one of 14 T-shirts labeled "Mad Mac's March" each day for the next two weeks. (Courtesy of Tom McAvoy.)

By the time all the pictures and interviews were finished, McAvoy was some 20 minutes behind schedule. As he pushed off, someone played a march on a loud speaker. He turned and saluted the crowd, then "laughing all the way" made his way through traffic on Route 30 to the Sauk Trail, the old LH. Some 173 miles of transportation history lay before him. (Courtesy of Tom McAvoy.)

A television reporter and cameraman accompanied him for about an hour on his way through Sauk Village. Art Schweitzer videotaped portions of his march elsewhere through eastern Illinois. Officials from Steger, Chicago Heights, Olympia Fields, and Matteson greeted and accompanied him through their territories. Upon reaching Harlem Avenue, he picked up his car and went home to sleep. The following day was planned as a stay-at-home day. (Courtesy of Tom McAvoy.)

On day three, Tom McAvoy reached New Lenox where he was greeted at Lincolnway High School by Darrell Holmquist (right). Holmquist, a western civilization teacher, had been instrumental in rescuing an authentic concrete marker from a cemetery on the east side of Joliet and having it installed in front of the school with a plaque describing its significance. Art Schweitzer was on hand to document McAvoy's visit. (Courtesy of Tom McAvoy.)

On day six McAvoy took a rest in Batavia where he caught up on notes. He had a network of helpers across the state. After walking an average of 13 miles each day, he was picked up by car at a designated spot, taken home or to a hotel for the night, and then returned to his starting point in the morning. He slept and ate well all the way. (Courtesy of Tom McAvoy.)

Blisters were a part of the "fun," but a duct tape wrap each morning soon eased the irritation. On the west side of Geneva, McAvoy, like so many before him, left the LH around Chicago for the prairies of Illinois. Seven days later, he put his tired feet into the cold waters of the Mississippi River at Fulton. He had walked 173.31 miles in 71 hours and 56 minutes. (Courtesy of Tom McAvoy.)

An object of change as well as a vehicle for movement, the LH around Chicago has evolved from a lonely route created to bypass a congested city to a local interurban dubbed miracle mile to being the destination of travelers itself. Hikers and automobiles come and go, but this stretch between Schererville, Indiana, and Geneva, Illinois, remains useful and resilient. (Courtesy of LHA collection/University of Michigan.)

Across America, People are Discovering Something Wonderful. Their Heritage.

Arcadia Publishing is the leading local history publisher in the United States. With more than 3,000 titles in print and hundreds of new titles released every year, Arcadia has extensive specialized experience chronicling the history of communities and celebrating America's hidden stories, bringing to life the people, places, and events from the past. To discover the history of other communities across the nation, please visit:

www.arcadiapublishing.com

Customized search tools allow you to find regional history books about the town where you grew up, the cities where your friends and family live, the town where your parents met, or even that retirement spot you've been dreaming about.